IMAGES
of America

JEWS OF
MORRIS COUNTY

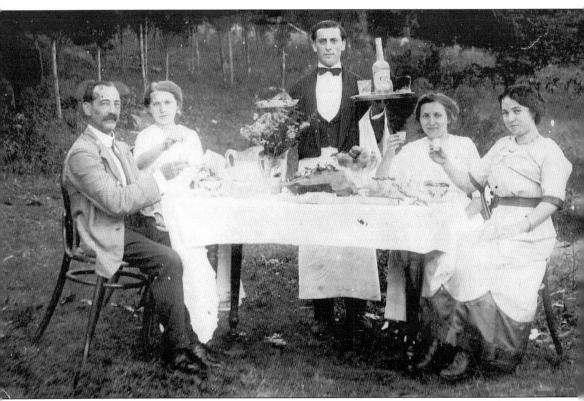

Advertised to New York City residents as only "90 minutes" from the renown Waldorf Hotel, guests were offered an alfresco lunch on the lawn of Morris County's first kosher hotel, the Sunrise Hotel, owned by Lena and Joseph Konner starting in 1904. (Courtesy of Leslie Mund.)

On the cover: Taken in February 1928, Dover's Jews are seen celebrating at a Bowery Night dinner and dance as members of a social group called the Unity Club. The group had 80 members in 1922 and Max Heller was president at the time. (Courtesy of the Schwarz family.)

JEWS OF MORRIS COUNTY

IMAGES of America

Linda B. Forgosh

Copyright © 2006 by Linda B. Forgosh
ISBN 978-0-7385-4565-3

Published by Arcadia Publishing
Charleston, South Carolina

Printed in the United States of America

Library of Congress Catalog Card Number: 2006925712

For all general information contact Arcadia Publishing at:
Telephone 843-853-2070
Fax 843-853-0044
E-mail sales@arcadiapublishing.com
For customer service and orders:
Toll-Free 1-888-313-2665

Visit us on the Internet at www.arcadiapublishing.com

*Inspired by a woman who loved all ideas, great and small,
this book is dedicated to my mother, Laura "Moggs" Berman,
my children David, Beth, and Lisa, and granddaughter Willow.*

Contents

Acknowledgments 6

Introduction 7

1. Morristown: Life on the Avenue 11

2. Dover: First Stop on the Morris Canal 37

3. Pine Brook: Looking at the Sunrise 59

4. Mount Freedom: Farewell to Little Broadway 71

5. After the War: Synagogues and Lake Communities 101

ACKNOWLEDGMENTS

Morris County's Jewish history is a relatively new find. Starting in 2000, the Jewish Historical Society of MetroWest, located in Whippany, New Jersey, revised its collections policy and mission statement to actively research, find, acquire, preserve, and exhibit the historical records that document Jewish life in Morris County. The search, truly a grassroots effort, produced enviable results. Hundreds of Morris County residents sat for oral history interviews, donated private collections, and, in some instances, actually hand-delivered photographs to our door specifically for this project. Happily, all 20 of Morris County's synagogues followed suit and donated their institutional records to our archives. As of spring 2006, we reached into our archives and created a traveling exhibit entitled "The Jews of Morris County: Early Settlers, Synagogues, Hotel Resorts, and Lake Communities" for use in local and state historical societies, museums, libraries, and synagogues. Interest in this history prompted the filming of a video tour of the exhibit slated for broadcast on local cablevision out of the County College of Morris. With the publication of *Jews of Morris County*, clearly a complement to this exhibit, we now have another way to access 150 years of remarkable Jewish history.

The technical support provided by archivist Jennifer McGillan was indispensable to the completion of this book. Likewise, an enormous scanning project was completed by society interns Jacky Grossberg and Jeffrey Bennett. A hearty thanks goes to all who generously granted permission to reproduce images. Credit for support of such research goes to the society's board members who saw the importance of preserving history that "will never come again." Equally important is the funding provided by the New Jersey Historical Commission, a division of the state department, the Jewish Community Foundation of the United Jewish Communities of MetroWest, and the members of the Jewish Historical Society of MetroWest. Important to mention are Ruth Fien, Jerry Fien, and Saul Schwarz, the founders of the Jewish Historical Society of MetroWest. Special thanks go to graphic designer, Marvin Slatkin, who makes our history so visually appealing and Yair Vinderboim for his ongoing participation in the society's history projects. Thank you greatly to Arcadia Publishing proofreader Sara Desharnais. Finally thanks go to Arcadia Publishing editor Erin M. Stone, who responded graciously to any and all requests along the way.

INTRODUCTION

Lured by reports of its glorious landscape, clean air, and available farmland, first generation Jewish immigrants living in crowded tenements in New York's Lower East Side and New Jersey's city of Newark made their way, albeit in small numbers, to Morris County, New Jersey, before the Civil War.

There are scant records or photographs to document the county's first Jewish family, Henry and Rosena Sire. What little there is can be found in Morris County's paper of record at that time, the *Jerseyman*. This newspaper's advertisements, as early as 1866, promoted Morristown's local Pocahontas Racetrack owned by "Sire and Sons."

Henry Sire had a large stable on Morristown's Speedwell Avenue, which did considerable business selling remounts to the Union cavalry. The couple's son, Benjamin, born in 1860, may have been the first Jewish child born in Morristown. What is certain is that Henry Sire and his two sons, Benjamin and William, were enormously successful businessmen.

By 1898, approximately 18 Jewish families were living in Morristown. Morristown was already a busy market town. Jewish merchants, who came primarily from eastern and central Europe, were attracted to Morristown by mercantile opportunities that came with providing goods and services to a crowd of prominent Wall Street financiers and other successful businessmen who owned extravagant estates and spent their summers in the area, and who made the daily commute on the train that ran between Morristown and New York City.

In 1902, acknowledging its socially prominent residents, the *New York Herald* declared Morristown the wealthiest city in America.

One by one, Morristown's Jews opened some kind of business. The majority set up shop on Speedwell Avenue which became the heart of Morristown's shopping district from the 1920s through the 1960s.

Stores such as M. P. Greenberger's (the town's first department store), Mintz dry goods, David and Harry Salny's men's clothing, Kantrowitz delicatessen, Cohen's kosher butcher (at one time Morris County's only kosher butcher), and Rose and Maurice Epstein, owners of Epstein's Department Store, located on Morristown's historic Green from 1912 to 2004, were but a few of the early-20th-century merchants who grew the town's prosperous business district.

A walk down "the Avenue," as it was called, was an adventure. These merchants were a creative lot. Bernard Friedman placed a large stuffed bear on the sidewalk each day to remind the foot traffic that he was a taxidermist and furrier. Harry Drell, who sold kosher chickens, kept live chickens in his window and added a neon sign, shaped like a chicken, that, when flashing, gave the impression of a huge chicken pecking food off the heads of passersby.

The next step was to establish a synagogue for the purpose of providing a center for Jewish life in Morristown. After meeting in five different rented halls and purchasing a Victorian era mansion from the Heywood Emmel estate in 1917, a full-service Jewish center opened its doors in 1929. It, too, was located on Speedwell Avenue where it has remained for more than 100 years.

Another group of Jewish settlers made their way to the Morris County town of Dover in the early 1880s. This group of Dover Israelites, as they referred to themselves, set up shop on Blackwell Street and grew a prosperous business district similar to Morristown's Jewish merchants.

Dover's Jewish merchants made a living from providing goods and services to the miners who worked in the nearby town of Mine Hill and the iron forges located at Revolutionary-era Piccatinny Arsenal. At this time, Dover was located on the Morris Canal. The canal barges transported such items as iron ore (the Dover area was rich in iron ore), farm products, and animal hides, all of which were shipped to the port city of Newark for use in the city's manufacturing industries.

Dover's Jews left a vivid portrait of their early years. Minutes ledgers starting October 4, 1882, offer an account of the activities of the Dover Hebrew Association, or "a group of eight men from Dover, one from Rockaway, one from Boonton, and one from Stanhope" that met at Dover's Mcdavid Hall. Member dues were 25¢ a month.

By 1897, Dover's Jews expanded their horizons and established the Dover Hebrew Literary Society. Meetings initially held in members homes shifted to rented rooms at local Elite Hall. That same year, the town's board of education gave permission to use an annex room for a Hebrew Sunday school, but, as the minutes reported, "we pay the janitor and the coal."

The group was charity-minded and patriotic. Beginning with the Spanish-American War in 1898, sums of money "for the relief of the needy families of our brave men while they are absent in their country's service" were awarded to a soldier's wife and children.

As Dover's Jewish community expanded, the need for a kosher cemetery became evident. A parcel of land off Crystal Street in Dover was available. In 1899, Dover's Jews established the Mount Sinai Cemetery Association, whose activities continue to be administered by an independent board affiliated with Morris Plains synagogue, Adath Shalom.

Among the most successful of Dover's early Jewish settlers, Leopold D. Schwarz purchased a patent in 1869 that provided technology for laying concrete pavements. His contracts with the town of Dover made him a wealthy man.

Following Schwarz's path to success, Max Heller, at age 18, was sent to Dover to manage Newark cousin Laser Lehman's grocery store in the early 1890s. Heller went on to own his own chain of grocery stores, including buying out Lehman's interests.

Sometime around 1915, Dover's minutes ledger mentions a Rabbi Heller who was involved in the planning of a Jewish community center. The debate centered around how to raise $20,000, the approximate cost of land and a building. Weekly Sabbath services had been held in rented stores and halls until the congregation received an unexpected windfall of $5,000 from Max and Bella Youngelson, owners of Youngelson's Department Store, for the purpose of building a synagogue.

Sheila Harris Mollen, whose grandfather Barney Harris opened a shoe store in Dover in 1897, recalled that once construction on the synagogue began, Bella Youngelson went around on a weekly basis to exhort the local Jewish merchants to give additional monies, goods, and services to the project. The synagogue, located on Orchard Street, opened its doors in 1936.

Dover Center's active membership of 250 families gradually dwindled to the point that there were almost no students available to attend its Hebrew school. In contrast, neighboring Temple Shalom of Booton, had Hebrew school students but no building to support its growing congregation. The two merged in 1988 to form Adath Shalom located in Morris Plains.

Along with the market towns of Morristown and Dover, Morris County had rich farmland that attracted a first generation of Jewish farmers. As early as 1894, accounts in the *Jerseyman* warned of "Jews trying to purchase farms" in Pine Brook and that "all indication will point to a Jewish incursion to this place." Pine Brook's first Jewish settlers were greeted with suspicion.

When hat manufacturer and owner of a cleaning and dyeing business Josef Konner was told to get out of the "smoke filled city" of Newark to save his health, he piled his family into a horse and wagon on a beautiful May Day and made the 12-mile trip to see a farm for sale in the town of Pine Brook, located in Montville Township. When the family pulled up to an old farm house, surveyed the 20-acre parcel of farmland and orchard in bloom, they decided to move.

Josef Konner was not cut out to be a farmer. Buying corn seed on account, Konner proceeded to plant the seed "wrong side up." The Konner children were obligated to retrace their father's steps, remove the corn seed, and replant it so it would grow.

The Jewish history of Montville and Pine Brook is told by Henrietta Konner Waxberg in her memoir *Looking Back to the Sunrise*. When Waxberg's daughter Miriam Bogart, heard that her mother was selling this book, she became concerned her mother was giving away family secrets. She retraced her mother's footsteps and returned the dollars her mother collected. Fortunate for the history community, enough copies stayed in circulation.

Among Henrietta's topics were Pine Brook's early Dutch settlers from whom the first Jewish settlers purchased farms; the establishment of the Konner family's Sunrise Hotel; life in rural Pine Brook; and incorporation of Morris County's oldest synagogue, or Congregation Chevra Agudas Achim Anchy, in 1896 on land donated by Josef Konner

Pine Brook expanded to become a resort community. Jewish farmers established boarding houses and hotels to attract summer vacationers. According to *None Outsings Parsippany*, these hotels were so popular that tents were set up in the fields when rooms were unavailable. The most famous of these family hotels was Konner's Sunrise Hotel located on Hook Mountain Road.

Pine Brook was not the only town in Morris County to boast successful, Jewish-owned hotels. A little further west, Mount Freedom, located in Randolph Township, experienced the growth of a hotel resort industry in the 1920s through the 1960s that rivaled New York's Catskill Mountain hotels. This was New Jersey's "borscht belt."

Piling all their worldly goods into a horse-drawn wagon, Max and Yetta Levine made a two-day trip from New York City's Lower East Side to Mount Freedom. The year was 1903. News of their arrival circulated among the town's farmers, who, as the wagon came into view, stood silently by the roadside watching the first Jewish settler enter the town.

Determined to make a go of dairy farming, the Levines, along with the newly arrived Saltz family, discovered they could not make a living as farmers. To supplement their income, Saltz opened a hotel in 1905, and Yetta Levine converted her farm house to a boarding house in 1909. Mount Freedom, which is located 1,200 feet above sea level, was an easy sell to city dwellers looking to escape the sweltering summer's heat. Word-of-mouth did the rest.

The Levines were part of a large, boisterous Steinberg family. Three brothers, Hyman, Julius, and Charles, and a sister, Rose, all settled in the area. Hyman and Anna Steinberg, married in 1911, had the first Jewish marriage recorded in Randolph Township. Their wedding invitation, written in English and Yiddish, was an acknowledgement that this first generation of Jewish immigrants had a foothold in an old and new world.

Saltz Hotel was the oldest and largest hotel as well as the last to close in 1978. The second largest was Sains Hotel, owned by Louis and Eva Sains. The Liebermans bought property on Brookside Road and erected Lieberman's Hotel. The Tenzer family operated a hotel of the same name. The Klode Hotel was located next to Ackermans on Calais Road. Pine Hill Lodge was known as a singles spot, and the Messer family built a hotel at Harbor Hills, which later became a summer camp.

Added to this mix of hotels, there were 45 bungalow colonies, many of which had some type of working relationship with the area hotels in order to entice renters with opportunities of nightly entertainment found at each of the hotels.

The bungalow colony industry was started by Bernard Hirschhorn who owned 100 acres in Mount Freedom as early as 1917. Hirschhorn, along with Isidore Rosenfarb were the prime movers in founding the Hebrew Congregation of Mount Freedom, now Mount Freedom Jewish Center, still located on Sussex Turnpike.

The 1940s and 1950s were the most prosperous times for the resort business in Mount Freedom. Factors such as air travel, the opening of the New York Thruway and Garden State Parkway, which made other resort areas accessible, the advent of air-conditioning, local swim clubs, trips to the Caribbean and Florida, unwillingness to modernize, exorbitant property taxes, and pressure from land developers spelled the end of Mount Freedom's glory days.

The history of Jewish life in Morris County is best viewed in two historic periods, before and after World War II. The 100-year-plus synagogue communities in the towns of Morristown, Dover, Pine Brook, and Mount Freedom document the county's earliest Jewish settlers.

The significant influx of Jews settling in Morris County after World War II were for various reasons, most of them having to do with affordable real estate and the opportunity to own summer homes in the lake communities of Lake Hopatcong, Lake Hiawatha, and White Meadow Lake.

Jewish life in Morris County continues to prosper and grow. From four 100-year-plus congregations, the county is currently home to 20 synagogues representing all branches of Judaism, including the practice of orthodox, conservative, reform, reconstructionist, and humanistic Jewish traditions.

One

MORRISTOWN
LIFE ON THE AVENUE

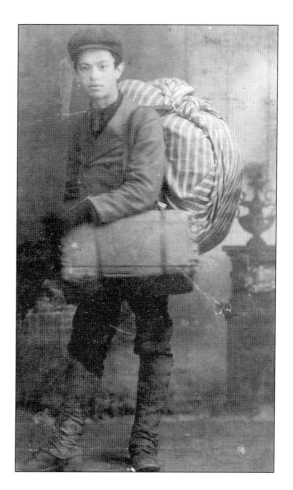

In 1908, at age 16, peddler Lewis Krauss traversed the Morris County countryside, eventually opened a candy store on Morristown's busy Speedwell Avenue, and is listed as a Life Member of Morristown Jewish Center. (Courtesy Harold Krauss.)

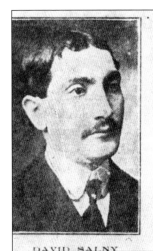
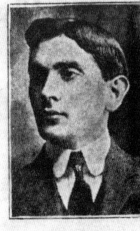

Salny brothers, David and Harry, started as peddlers before opening a haberdashery on Speedwell Avenue. Their 10th anniversary in business was promoted in 1907 in Morristown's paper-of-record, the *Jerseyman*. Both men were founding members of Morristown Jewish Center in 1929. Both served as synagogue presidents. (Courtesy Jane Cee Redbord.)

Banquet and Entertainment
given by the House of Israel
in honor of the 10th Anniversary of the
Ladies' Auxiliary
at Shary's Manor
104 Clinton Avenue, Newark, N. J.
Sunday evening, February 12th, 6 P. M.
Tickets $2.50

Morristown's Jews were connected to Newark's Jewish community through family and business ties. When the synagogue's Ladies Auxiliary held its first fund-raising dinner to promote the building of a Jewish center in Morristown, the event was held at Newark's popular Schary Manor. The largest single donor was Felix Fuld, co-owner of one-time Bamberger's Department Store. (Courtesy Jewish Historical Society of MetroWest Archives.)

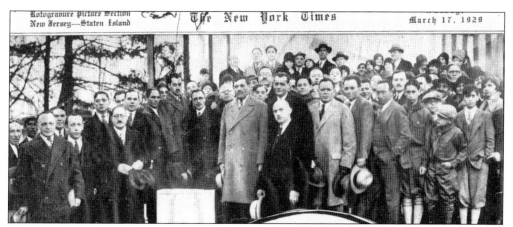

Morristown's Jewish Community Center, Beit Yisrael, or House of Israel, was dedicated on March 17, 1929. Incorporated in 1899, it took 30 years of meeting in five different halls before erecting a full-service synagogue that acted as a magnet for Jewish life. (Courtesy Sidney M. Schlosser.)

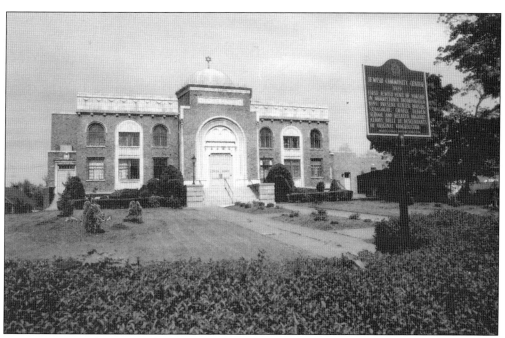

Morristown Jewish Center is located in historic Speedwell, a designated historic district on New Jersey's preservation maps. It is Morris County's oldest, continuously operating synagogue in its original location. (Courtesy Jewish Historical Society of MetroWest Archives.)

A ceremonial trowel and key to the front door of Morristown's synagogue was presented to David Salny on the occasion of laying the cornerstone in 1929. Since the trowel was symbolic of "working on the job," Salny was sworn in as a temporary member of the union to make sure there was no breach of the union's contract. (Courtesy Jerome S. and Abby Salny.)

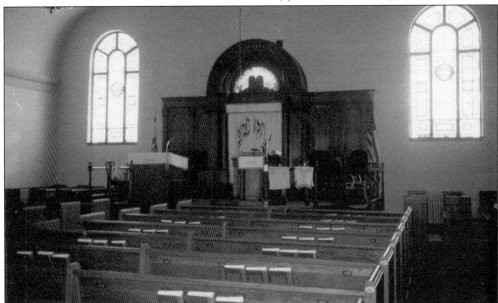

The center's sanctuary was build to accommodate 524 worshippers. With only 50 families in 1929, it was clear that synagogue leaders had faith that other Jewish families would join them. (Courtesy Jewish Historical Society of MetroWest Archives.)

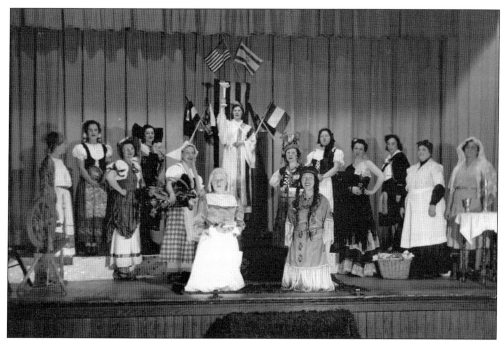

This "tableaux" celebrating America's diversity was representative of the many kinds of activities hosted at Morristown's Jewish Center early on. (Courtesy Jane Cee Redbord.)

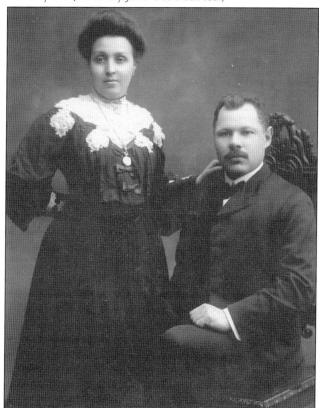

Among Morristown's earliest Jewish families, the Glicks opened a hardware store on Speedwell Avenue in the 1930s. (Courtesy Ed Brody.)

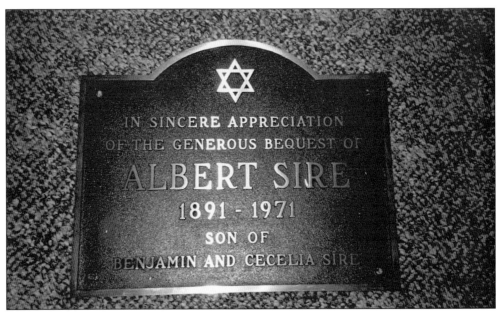

A plaque acknowledging a $25,000 bequest received from Albert Sire in 1971 is in the lobby of the Morristown Jewish Center. Sire was never a member of the congregation. However, the Sire family was the first Jewish family to settle in Morristown as early as 1860. Henry Sire sold remounts to the Union Army and owned the local Pocahantas Racetrack. (Courtesy Morristown Jewish Center-Beit Yisrael.)

Giza, or Gussie Roth, spent her days at the synagogue running a profitable thrift shop and her nights at synagogue meetings. She also sponsored an annual Roth Sisterhood luncheon at her home from the 1940s through the early 1960s. (Courtesy Goldie Feldman.)

Gussie Roth, wife of successful movie theater owner, Harry Roth, had a cottage industry of making aprons in her home. One size fit all. Profits from the sale of the aprons supported various synagogue activities. Roth's son, William, is holding one of a few remaining hand-sewn aprons. (Courtesy Jeanette Epstein.)

A certificate of incorporation for a Jewish cemetery in Morristown, initially founded in 1903 as Morristown Hebrew Cemetery Association, documents the name change to Beth Israel Cemetery in 1927. At this time, day-to-day operations of the cemetery were administered by a nationwide fraternal organization, or International Order of Brith Abraham. (Courtesy Jewish Historical Society of MetroWest Archives.)

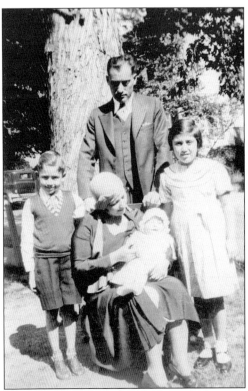

Milton and Esse Schlosser with children, from left to right, Sidney, Babette, and Elaine, were among Morristown's earliest Jewish families. Schlosser was the second president of Morristown Jewish Center and owned the town's Washington Hotel in the 1930s. (Courtesy Alise Ford.)

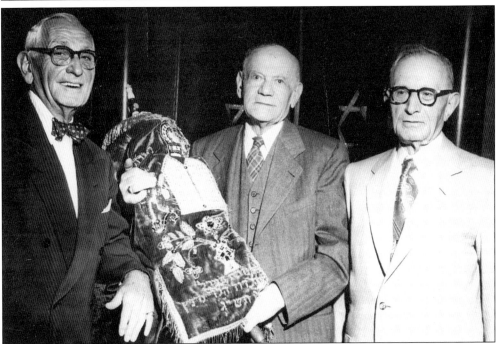

Morristown's first Torah, or sacred scroll, was purchased in 1899 for $35 by members of the Mintz family. Holding this Torah are founding members, from left to right, Harry Salny, Harry Mintz, and Morris Rosenberg in the 1950s. (Courtesy Morristown Jewish Center-Beit Yisrael.)

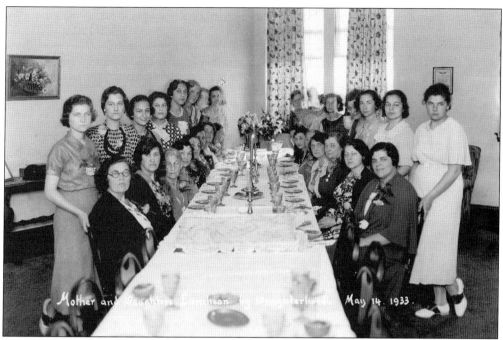

A mother and daughter banquet was an annual sisterhood event hosted from the early 1930s through the 1960s. (Courtesy Morristown Jewish Center-Beit Yisrael.)

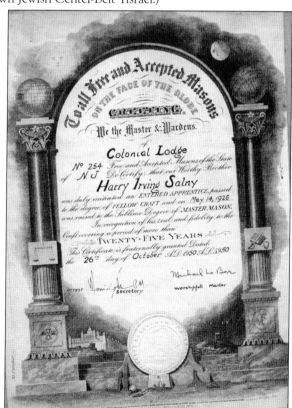

Morris County has a Jewish Masonic Order, the Colonial Kane Lodge, of which Harry Salny, long-time Morristown resident, was a member. (Courtesy Jane Cee Redbord.)

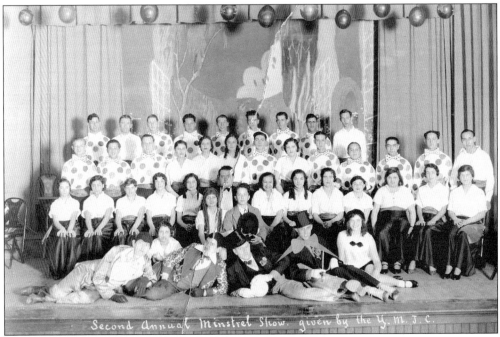

More than just a house of worship, Morristown's Jewish Center was built with a stage for all types of performances. (Courtesy Morristown Jewish Center-Beit Yisrael.)

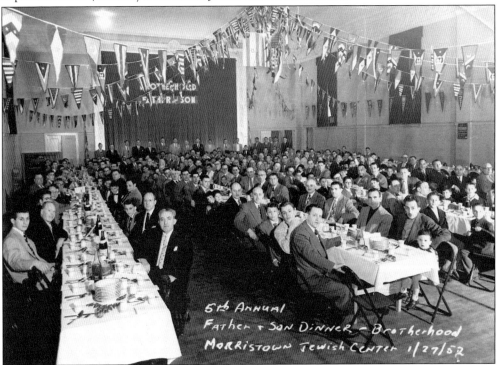

Father-and-son dinners sponsored by the brotherhood were held throughout the 1950s. Now it is the Men's Club. Sisterhood members prepared and served the meal. (Courtesy Morristown Jewish Center-Beit Yisrael.)

The center printed a supplement to its newsletter for its men in service during World War II. Seen wearing his military uniform, congregant Jerome Salny resumed private life and became first president of the Morristown Jewish Center's Brotherhood in 1947. (Courtesy Morristown Jewish Center-Beit Yisrael.)

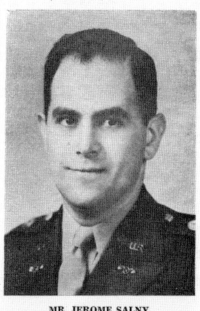

The Harry Salny family were regulars at many of the dinners and events hosted at the synagogue. (Courtesy Jane Cee Redbord.)

In an era when ladies wore extravagant hats, Sid Salny (extreme right) made her hat for this 1950s luncheon. (Courtesy Jane Cee Redbord.)

The Morristown Jewish Center hosted troops of Boy Scouts and Girl Scouts, and this 1948 troop of Brownies. Group leader (standing, left) Belle Zudick Wasserman was well known in the community for her active participation in all things Jewish. (Courtesy Morristown Jewish Center-Beit Yisrael.)

Hebrew school principal, Marge Elkind (standing), is featured with students celebrating a Passover seder. (Courtesy Morristown Jewish Center-Beit Yisrael.)

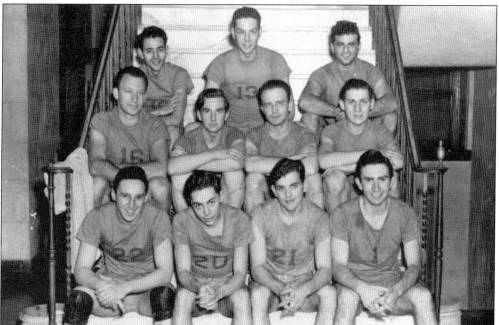

In 1947, the Morristown Jewish Center Athletic Club championship basketball team had a 13-game winning streak. The leading scorers were Mickey Solodar and six-foot-seven-inch Dave Lictenstein; the captain was Milton Rubin, and the rest of the team consisted of Milt Goldband, Stan Rosenfarb, Stan Needell, Morty Ehrlich, Joe Dubinsky, Al Forman, Gerry Sicherer, and Coleman Leff. (Courtesy Morristown Jewish Center-Beit Yisrael.)

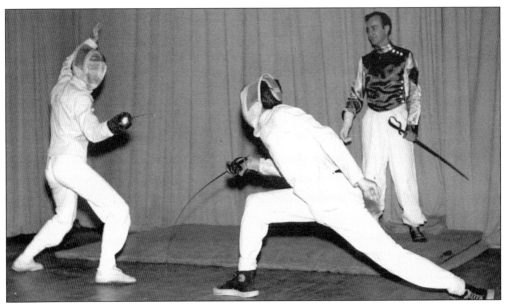

Morristown's Jewish Center in the 1940s and 1950s maintained a regulation-size basketball court and two bowling alleys. The center hosted wrestling matches, and even sponsored fencing lessons. (Courtesy Morristown Jewish Center-Beit Yisrael.)

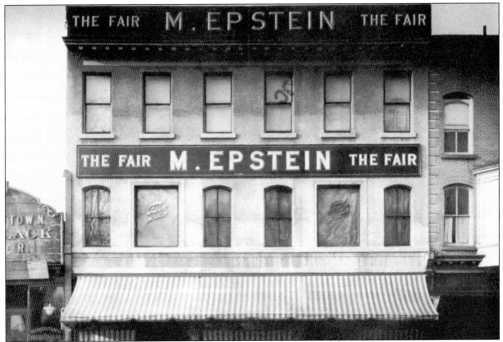

Maurice and Rose Epstein's The Fair preceded Epstein's Department Store located on Morristown's historic green starting in 1912 and closing in 2004. The business started with Rose Epstein's hand-sewn, custom-ordered "waists." Maurice was considered the moving force for founding and sustaining the synagogue. Maurice was synagogue president for 10 years from 1929 until 1939. He bought a life insurance policy which paid off the mortgage in 1947. (Courtesy Jewish Historical Society of MetroWest Archives.)

Speedwell Avenue, or "the Avenue," was home to numerous Jewish merchants. The group formed a merchant's association and elected H. E. Sontag as its first president in 1951. (Courtesy Eleanor Cohn.)

H. E. Sontag Head Of New Speedwell Ave. Store Group

Herman E. Sontag was elected president of the newly organized Speedwell Avenue Merchants Association at a meeting held at 28 Speedwell avenue.

Other officers named included Alexander Lasky, chairman of the Retail Division of the Chamber of Commerce, and Sol Zisk as vice-presidents; Sam Schwartz, treasurer, and Shelley Greenberg, secretary.

Approximately 40 merchants attended the organizational meeting of the association, formed primarily to improve parking and shopping conditions on the avenue.

HERMAN E. SONTAG

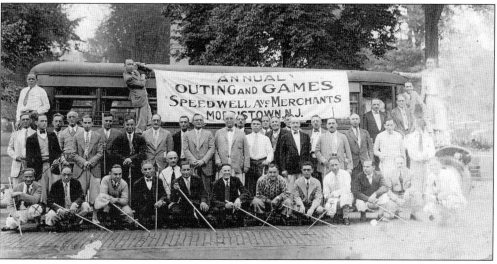

Morristown's Speedwell Avenue Merchants Association was formed to influence policy decisions for creating an attractive streetscape and adequate parking in the town. (Courtesy Jewish Historical Society of MetroWest Archives.)

Members of the center received monthly newsletters. During the 1940s and 1950s it was *The Center Bulletin*. (Courtesy Morristown Jewish Center-Beit Yisrael.)

First lady Eleanor Roosevelt (standing far right) joined Harry and Anna Salny at their home on Egbert Hill. Seated is daughter-in-law Sid Salny. (Courtesy Jane Cee Redbord.)

A 1963 letter to Sid Salny was from First Lady Jacqueline Kennedy's social secretary, Letitia Baldridge, regarding an invitation to the synagogue's annual Art-O-Rama fund raiser. (Courtesy Jane Cee Redbord.)

```
                    THE WHITE HOUSE
                       WASHINGTON

                              March 12, 1963

Dear Mrs. Salny,

     I am writing on behalf of Mrs. Kennedy to
thank you for your letter of March 5.

     Mrs. Kennedy has asked me to express her
appreciation for your gracious invitation to be your
dinner guest on May 4th. This was most thoughtful
of you.

     The demands of Mrs. Kennedy's official
schedule this Spring, however, will preclude her
acceptance to both the dinner invitation and the
invitation to the First Annual Morristown County
Art-O-Rama.

     Mrs. Kennedy sends you and each one involved
in this worthy project her personal best wishes for
what we know will be a distinguished and enjoyable
affair.

                              Sincerely,

                              Letitia Baldrige
                              Social Secretary

Mrs. Milford Salny
Egbert Hill
Morristown, New Jersey
```

Sid Salny (left) headed a committee of Morristown's Jewish women who planned, scouted, selected works of artists, and promoted an annual Art-O-Rama in the 1960s. (Courtesy Jane Cee Redbord.)

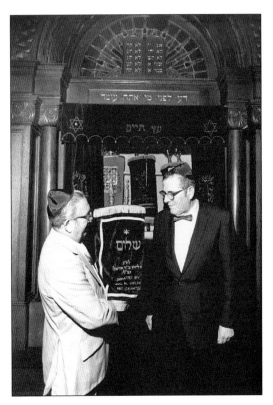

Cantor Arthur Sachs (left) congratulates long-time member Herman Frigand for his years of devoted service to the synagogue. (Courtesy Jewish Historical Society of MetroWest Archives.)

A second generation of Morristown Jewish leaders were honored at an Israel Bond dinner. The event was held at Mount Freedom's Saltz Hotel. (Courtesy Jane Cee Redbord.)

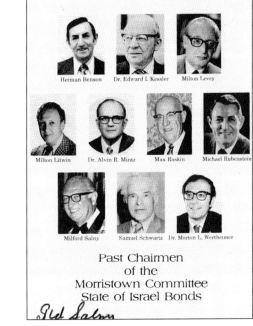

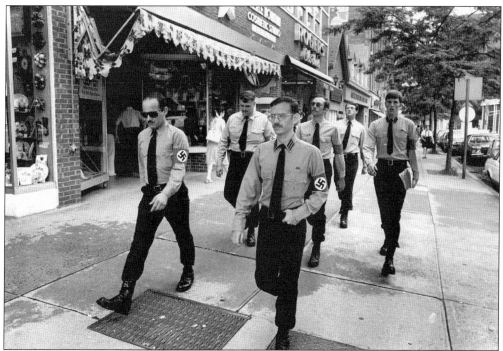
Anti-Semitism reared its ugly head from time to time. A group of Nazi supporters marched around the town's historic green in 1978. (Courtesy Jewish Historical Society of MetroWest Archives.)

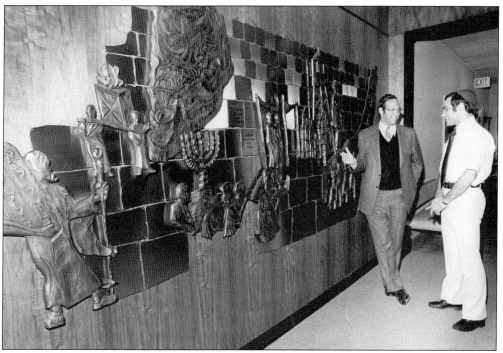
A wall sculpture suggestive of Jerusalem's ancient Western Wall features Rabbi Sheldon Weltman (standing closest to the wall) in the 1980s. (Courtesy Morristown Jewish Center-Beit Yisrael.)

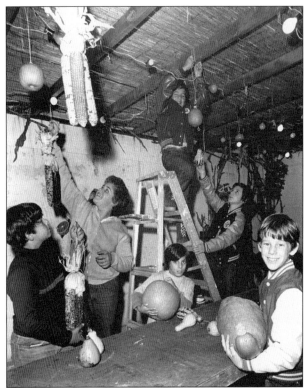

Every year, synagogue youngsters decorate a traditional sukkah, or open-air booth where ancient Hebrews are said to have eaten meals during the fall harvest festival of Sukkot. (Courtesy Morristown Jewish Center-Beit Yisrael.)

Long-time congregants, shown from left to right, Harold Krauss, Jeanette Epstein, "Rookie" Friedman, unidentified, and Marge Elkind pose for a congratulatory photograph. (Courtesy Morristown Jewish Center-Beit Yisrael.)

Eleanor Chimoff, whose father owned Kantrowitz Delicatessen on Speedwell Avenue, and husband, Raphael, or Ray Chimoff, past-president of the congregation, are sources for the history of the Jewish community. (Courtesy Morristown Jewish Center-Beit Yisrael.)

Synagogue historian Lewis Stone, with son Jonathan and wife Julie at hand, recall Julie's father, Albert Abraham, the first Jewish doctor to have staff privileges at Morristown Memorial Hospital, and mother, Helen Abraham, president of the sisterhood in 1958. Also featured is congregant Gail Gerwin on the right. (Courtesy Jewish Historical Society of MetroWest Archives.)

Seymour Epstein was the son of department store owners Maurice and Rose Epstein. Seymour served as president of the United Jewish Federation of Morris-Sussex, 1973–1975. (Courtesy Jewish Historical Society of MetroWest Archives.)

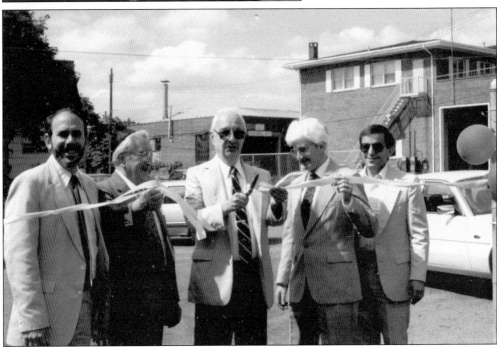

The ribbon-cutting ceremony for completion of the synagogue's parking lot features, from left to right, Rabbi David J. Nesson, cantor Arthur Sachs, Mayor Norman Bloch, cantor Maimon Attias, and unidentified. (Courtesy Morristown Jewish Center-Beit Yisrael.)

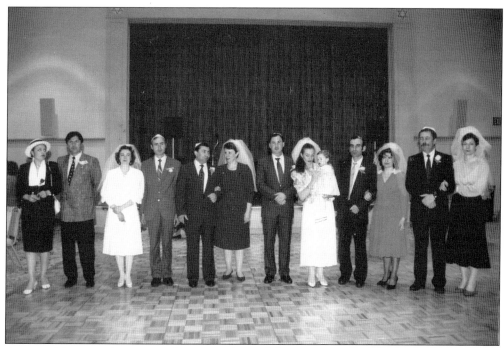

As new citizens to America and new members of the congregation, Russian couples renewed their marriage vows in a traditional Jewish ceremony in 1991. (Courtesy Morristown Jewish Center-Beit Yisrael.)

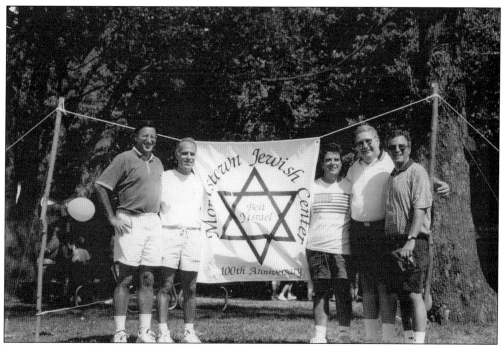

A congregational picnic was one of the many events that marked the center's 100th anniversary in 1999. (Courtesy Morristown Jewish Center-Beit Yisrael.)

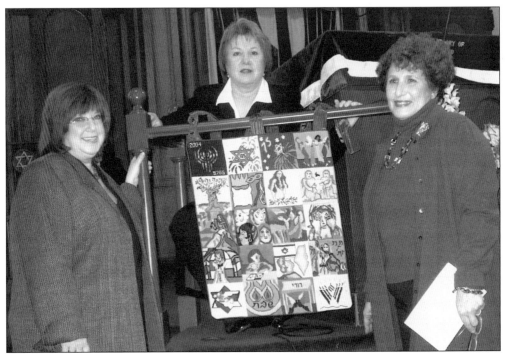

From left to right, the sisterhood's Rachel Rosenheck, Sharon Barkauskas, and Celeste Reingold presented a *bayn aliyot* to cover the Torah scroll between Torah readings. (Courtesy Morristown Jewish Center-Beit Yisrael.)

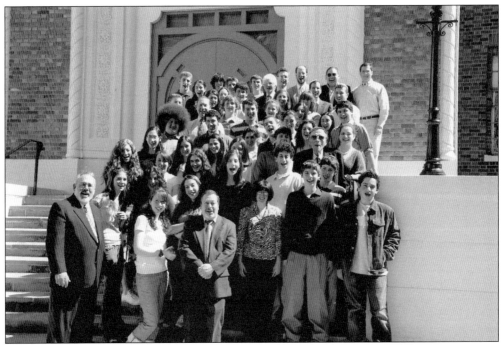

Herman Frigand started a youth group called the minyonaires in 1962. The group is seen celebrating its 36th anniversary. (Courtesy Morristown Jewish Center-Beit Yisrael.)

Cantor Maimon Attias began his tenure in 1980. His spirited singing and chanting of traditional and newly composed melodies attracts a cadre of loyal followers. (Courtesy Morristown Jewish Center-Beit Yisrael.)

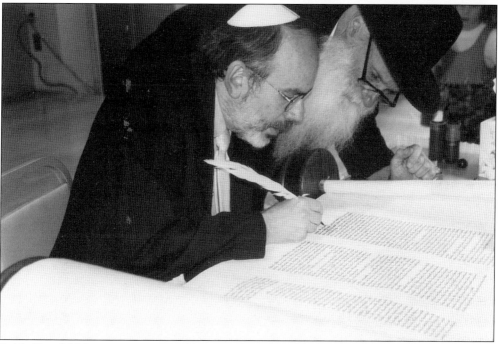

Rabbi David J. Nesson, accompanied by a Torah scribe, adds a line to the Torah. The creation of a new Torah, or Siyyum Torah, was sponsored by Celeste and David Reingold in honor of their daughter Stephanie's bat mitzvah. (Courtesy Morristown Jewish Center-Beit Yisrael.)

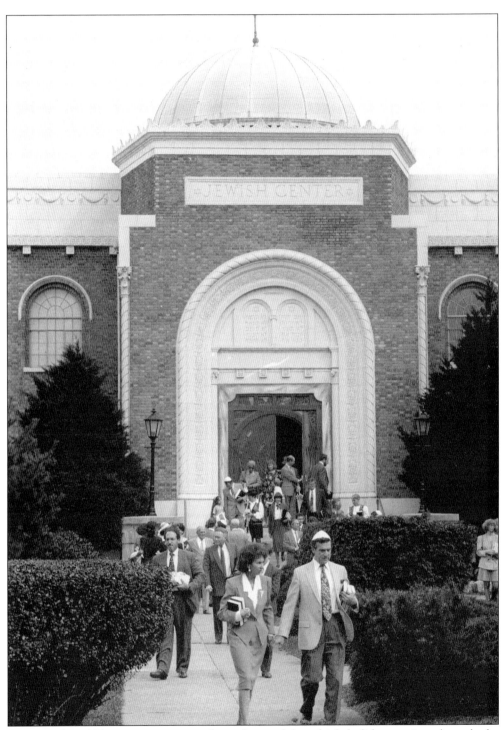

For more than 100 years, congregants have departed from high holiday services through the synagogue's front doors onto the sidewalk facing Speedwell Avenue. A street named Beit Yisrael Way, was established by the Town of Morristown to commemorate the congregation's milestone anniversary. (Courtesy Morristown Jewish Center-Beit Yisrael.)

Two
DOVER
FIRST STOP ON THE MORRIS CANAL

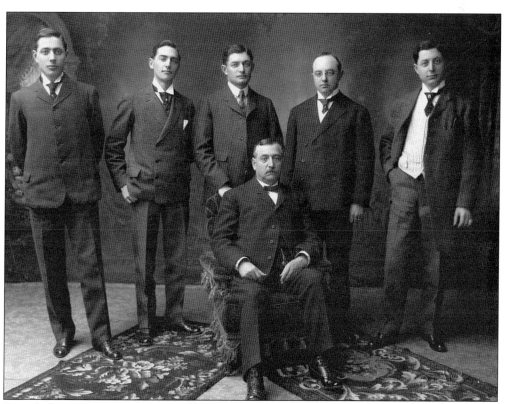

Dover's first settler in 1869, Leopold D. Schwarz (seated), with sons (left to right) Mark H., Harry L., Irving, Sidney S., and Eugene, purchased a patent that provided technology for laying concrete pavements. His contracts with the town made him a wealthy man. He was also the founder of the Dover Electric Light Company. (Courtesy the Schwarz family.)

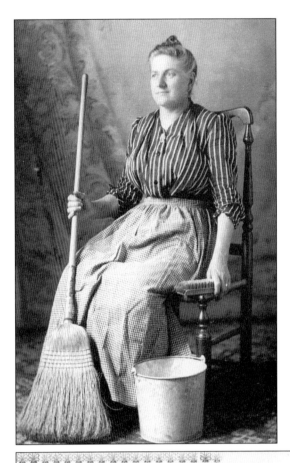

Hannah Schwarz's sons convinced their mother to be photographed in housecleaning attire. Among her activities, Hannah organized a Reform Sunday school in her house prior to 1883. (Courtesy the Schwarz family.)

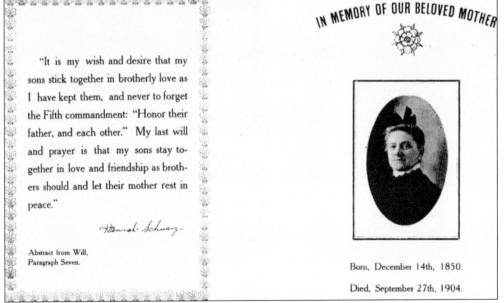

Hannah Schwarz's "in memoriam" card was prepared and distributed by her sons to Dover's Jewish community. (Courtesy the Schwarz family.)

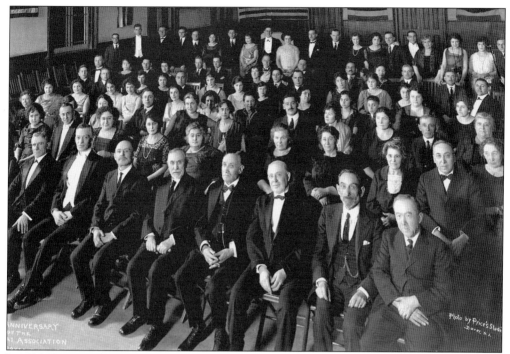

In 1899, Dover Hebrew Literary Society bought one and a half acres for a cemetery and established the Mount Sinai Cemetery Association. The group celebrated their 25th anniversary in 1922. (Courtesy Sheila Harris Mollen.)

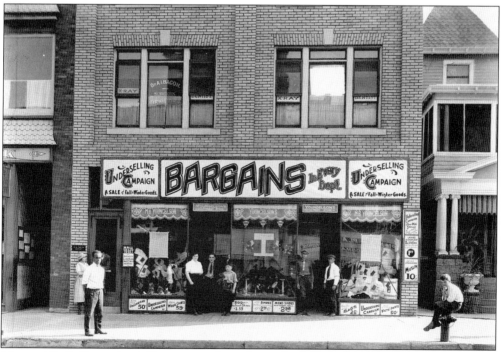

Max and Bella Youngelson's Department Store, located on Blackwell Street as early as 1910, sold goods to area miners living in the nearby town of Mine Hill. (Courtesy James Youngelson.)

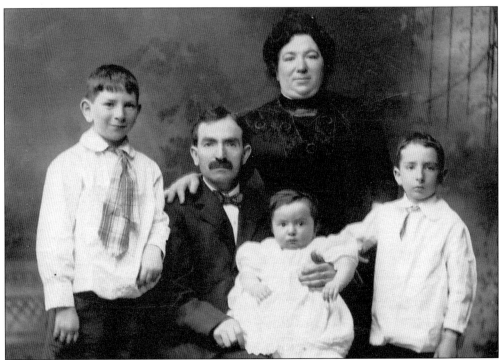
The Youngelson family, Max, Bella, and sons (from left to right) William, Gary, and Irving in the early 1900s, are credited with the founding of Dover's synagogue. The couple made an unexpected donation of $5,000 to the informal Jewish community in 1917 for purchase of land and a synagogue building. (Courtesy James Youngelson.)

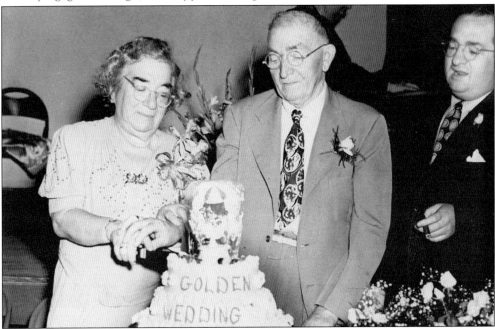
Max and Bella Youngelson celebrated their 50th wedding anniversary in 1946 in the banquet hall of the Dover Jewish Center, or Adath Israel, located on Orchard Street. (Courtesy James Youngelson.)

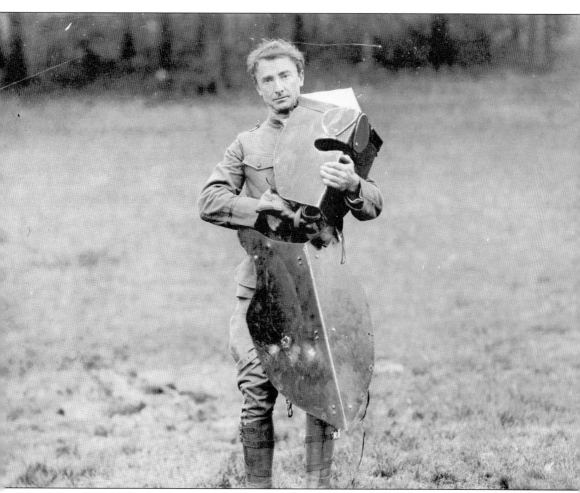

Inventor of World War I militaria, or the Brewster-Heller armor protector, Dr. Guy Otis Brewster wore the armor for a test demonstration to the U.S. War Department in 1917. After receiving a patent, the two men, Guy O. Brewster and Emil Heller, wanted a payment of $600,000 for this invention. (Courtesy Franklin Hannoch Jr.)

Farewell Dance
TO
Men in Service

AT

Picatinny Arsenal

Given by
JEWISH WELFARE BOARD
Morris County Branch

High School Auditorium
Dover, New Jersey
March Sixth, Nineteen Nineteen

Dance programs were printed for a dance to be held in honor of Dover's servicemen during World War I. (Courtesy Sidney M. and Ethel F. Schwarz)

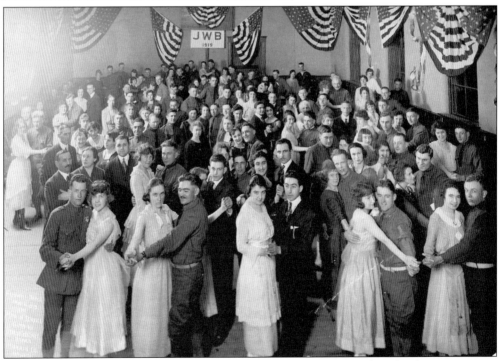

World War I soldiers danced their farewell night away at Dover's High School gymnasium in 1919. (Courtesy Sidney M. and Ethel F. Schwarz.)

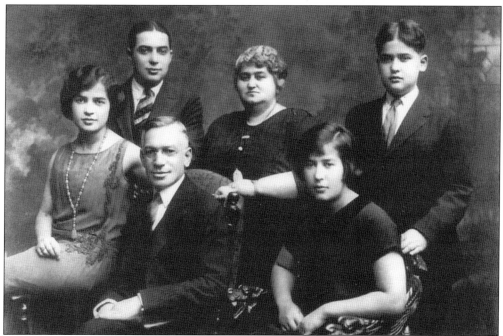

The Hellers were a prominent family. Seen here, from left to right, are (first row) Carolyn, Max, and Ruth; (second row) Gustave, Jennie Marx Heller, and Franklin. Max came to Dover at age 18 and built a successful chain of produce stores, invested in real estate, and helped found Dover Trust Bank. (Courtesy Franklin Hannoch Jr.)

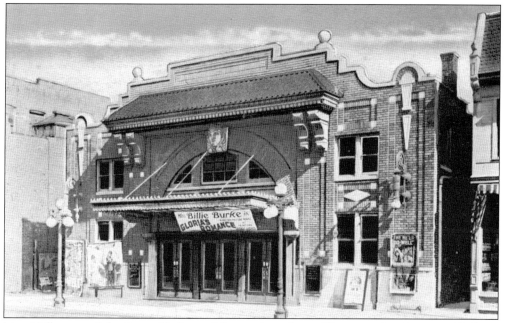

Max Heller owned the Dover Playhouse Theater. In order to fill seats in the afternoon, Heller, a man with an imagination, constructed what he called a "crying room" in the theater. This room had a large glass window where young mothers could leave their children, watch a movie, and keep an eye on their youngsters at the same time. (Courtesy Franklin Hannoch Jr.)

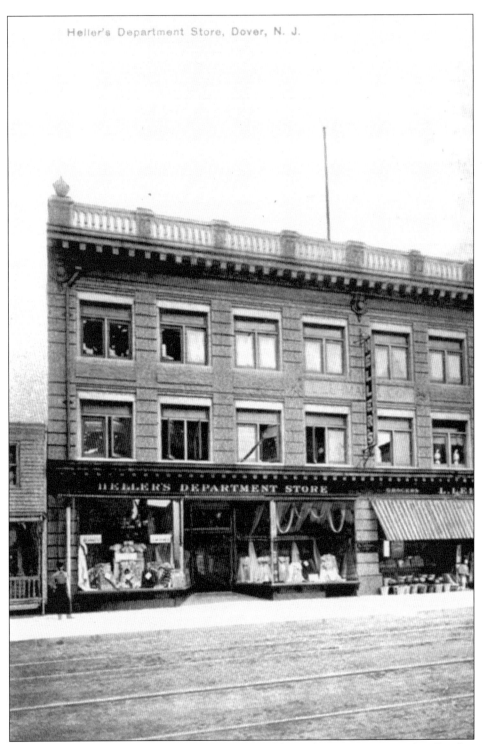

First owner Laser Lehman put his name on this building where it remains today. Purchased later by Max Heller, local residents knew it as the Heller Department Store. The building is still located on Blackwell Street. (Courtesy Franklin Hannoch Jr.)

Benjamin and Cecelia Furstman with daughter Ethel were among Dover's earliest Jewish settlers. Benjamin was a partner in Furstman and Feinberg men and women's clothiers located on West Blackwell Street. (Courtesy the Schwarz family.)

Cecelia and Ethel Furstman are standing at the corner of Birch Place, location of Dover's popular Price's photography studio. The woman on the right is unidentified. (Courtesy the Schwarz family.)

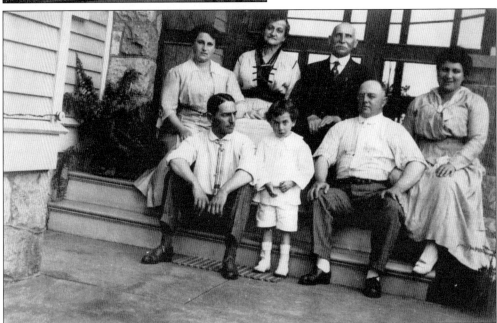

The May and Schwarz families are featured with grandson Sidney M. Schwarz in 1914. (Courtesy the Schwarz family.)

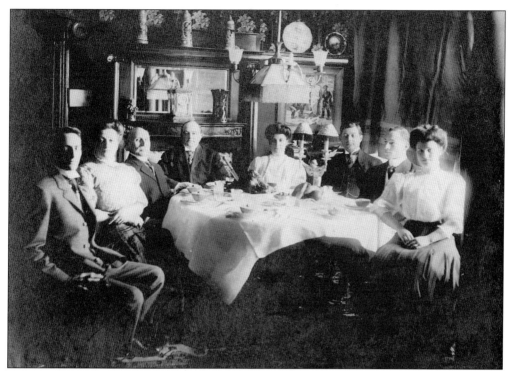

At home in East Orange in 1908, members of the Schwarz family had business ties in greater Newark's Jewish community. (Courtesy the Schwarz family.)

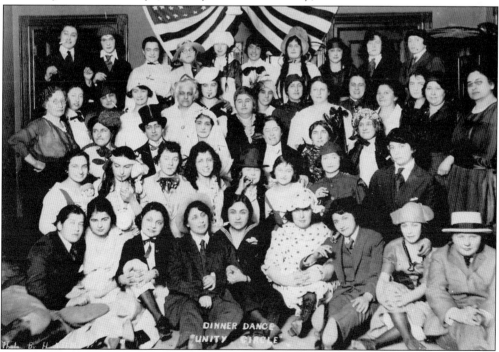

Frequent social gatherings were sponsored by Dover's Unity Club. This photograph was taken in 1920. (Courtesy the Schwarz family.)

There were numerous unity clubs established at the beginning of the 20th century. The club's newsletter kept track of activities regarding Jewish life in Dover. (Courtesy Jewish Historical Society of MetroWest Archives.)

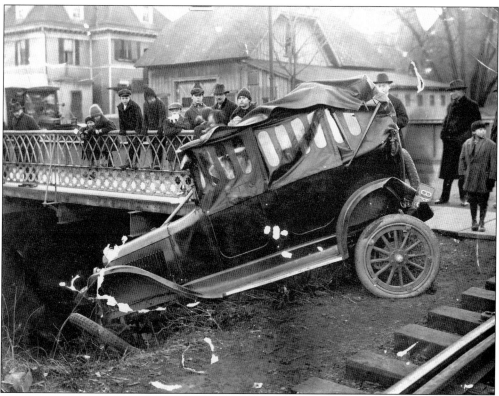

Headlines and a photograph in the *Dover Advance* reported what was left of Benjamin Furstman's car after it was hit by a train in 1921. (Courtesy the Schwarz family.)

No. 1432 COMMEMORATING THE INSTALLATION
OF
ELECTRIC TRAIN SERVICE
ON THE
LACKAWANNA RAILROAD
(DOVER - NEW YORK)
Thursday, January 22, 1931
Extending Electric Service with Dover, Wharton, Rockaway, Denville, Mt. Tabor, Morris Plains to New York

The Lackawanna Railroad opened service from New York to Dover in 1931. Morris County's steady growth was due to development of interstate highways, bus, and train travel. (Courtesy the Schwarz family.)

Morris Ginsberg and family operated a working cattle farm in nearby Mine Hill. Skins from farm animals were sent to Newark's leather manufacturers. (Courtesy Sharon Barkauskas.)

Harry Ginsberg was a member of the meat cutter's union during World War II. (Courtesy Sharon Barkauskus.)

Harry Ginsberg was owner of Tri-County Beef Company in 1936. (Courtesy Sharon Barkauskus.)

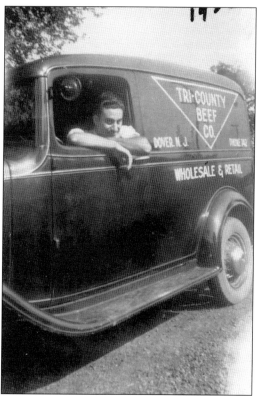

The Friedman brothers, (from left to right) Gerson, Harris, and Eugene, grew up in Dover's oldest house, or Hurd House, a small portion of which can be seen in the background. (Courtesy the Schwarz family.)

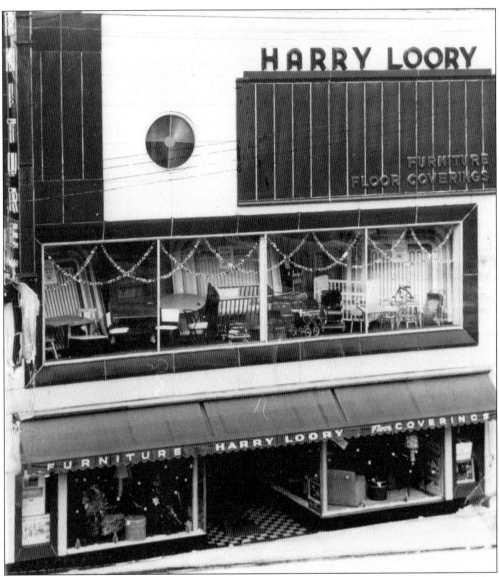

Max Loory came to Dover in 1911 and opened a ladies dry goods store. Son Harry joined his father in the business. Harry married Eva. He went into business for himself and opened Harry Loory's Fine Furniture Store in 1931. The business is still there. (Courtesy Mel Loory.)

Harry L. Schwartz was a prominent civic leader and philanthropist in a league with Newark department store owners Louis Bamberger and Felix Fuld. Schwarz was a founder of Dover General Hospital. His Pine Hill estate became the site for the hospital. (Courtesy the Schwarz family.)

Harry L. Schwarz, fourth from left, was honored by his peers for 60 years as a Morris County realtor. The event was held at the Dutton Hotel in Dover in 1957. Schwarz Realtors has been doing business at the same Sussex Street location since 1897. (Courtesy the Schwarz family.)

In 1949, a testimonial dinner honored Alexander Davis's 50 years of continuous service as an officer of the Mount Sinai Cemetery Association. Davis (center) is receiving a watch from Harry L. Schwartz. (Courtesy Sidney M. and Ethel F. Schwarz.)

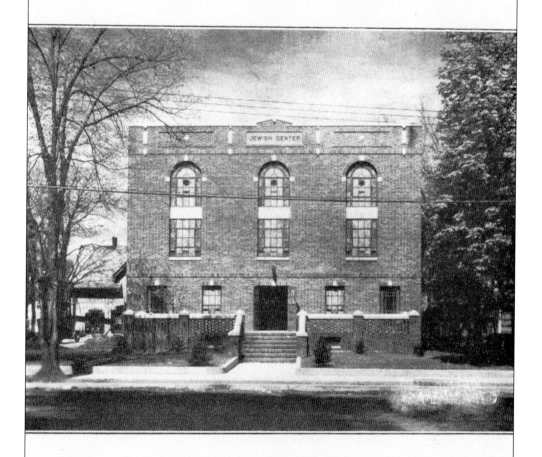

The cover of a souvenir journal documents the dedication ceremony for Dover's Orchard Street synagogue in 1936. The synagogue relocated to 18 Thompson Street in 1965. (Courtesy Sheila Harris Mollen and Lisa Monday.)

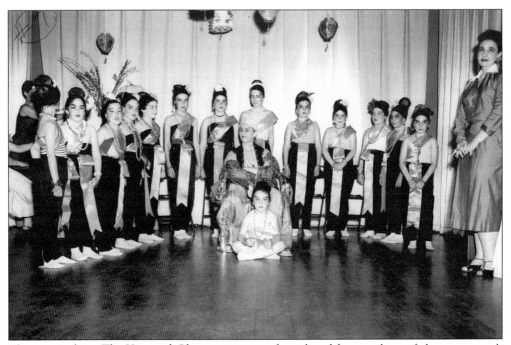

The cast is from *The King and Chaya*, written and produced by members of the synagogue's sisterhood in the 1950s. (Courtesy Eleanor Cohn.)

Cast for the sisterhood play *The Tale of Three Sisters* features, from left to right, Sheila Mollen, Ada Rosen, and Jessie Gruber performing for the Ladies Auxiliary of Dover Jewish Center donor dinner in 1956. (Courtesy Eleanor Cohn.)

Dover Jewish Center Sisterhood presented an annual Woman of Valor award. The recipient of the award is Gay Ginsberg (left) receiving her president's pin from Sheila Mollen. (Courtesy Sharon Barkauskas.)

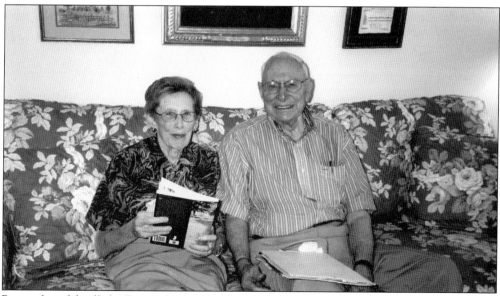

Remembered fondly by Dover's Jews, Sidney M. and Ethel Schwarz grew up, married, and raised a family as active members of the greater Morris County Jewish community. (Courtesy Jewish Historical Society of MetroWest Archives.)

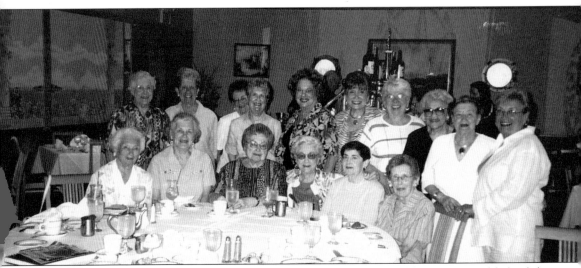

Dover's one-time sisterhood members continue their life-long friendships at a monthly birthday luncheon long after the merger of Dover Jewish Center with Temple Shalom of Boonton in 1988. From left to right they are as follows: (first row) Eleanor Cohn, Roz Andersen, Trudy Weinstein, Mimi Willinger, Natalie Basch, and Ethel Schwarz; (second row) Diane Loeb, Mickey Silberman, Harriet Malkin, Claire Schulman, Jeanie Rudensky, Ann Small, Sheila Mollen, Annie Fink, Laura Millman, and Ada Rosen. (Courtesy Jewish Historical Society of MetroWest Archives.)

Three
PINE BROOK
LOOKING AT THE SUNRISE

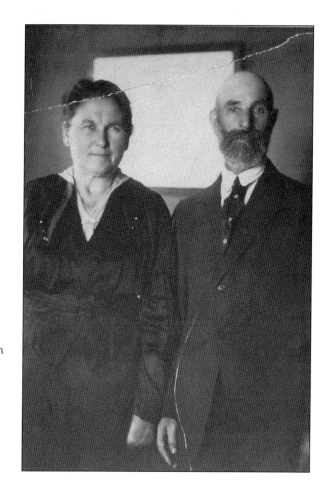

Abram and Frieda Handleman purchased a farm with funds from Frenchman Baron Maurice de Hirsch and settled in Montville Township in 1890. As a farmer with a growing family, the Handleman's moved to a farm on Horse Neck Road. The couple took in summer boarders to supplement their farm income. Crops were driven to Newark's markets by horse and wagon via Bloomfield Avenue. (Courtesy Merna Most.)

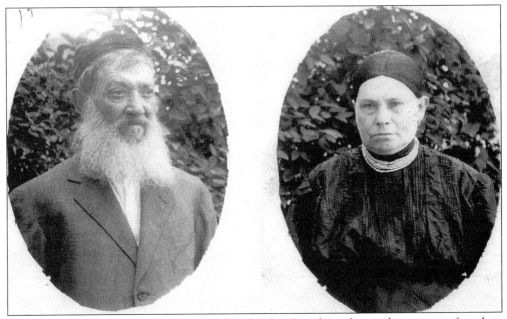

The Ershowsky family were among Pine Brook's first Jewish settlers and synagogue founders. Rachel Ershowsky (right) was a practicing mid-wife. Moshe Ershowsky retired to Pine Brook from his New York City meat business. The couple are buried in Pine Brook's congregational cemetery. (Courtesy Cyrene Aksman.)

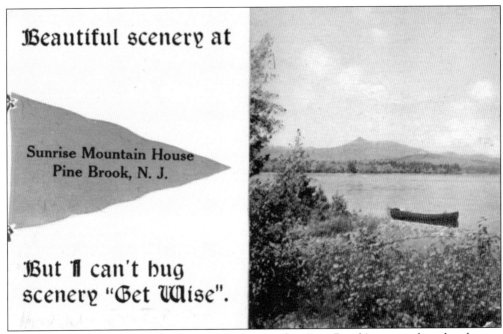

Postcards promoted the landscape attractions surrounding Pine Brook's summer boarding houses and hotels. (Courtesy Leslie Mund.)

The only history ever written about Pine Brook's Jewish farmers and hotel owners was written by Henrietta Konner Waxberg in 1960. Henrietta's daughter, Judge Miriam Bogart, was concerned that her mother revealed family secrets and went around returning the $1 purchase price of her mother's history book to neighbors and friends. Streets named for Waxberg, Konner, Bogart, and Schneider in Pine Brook remind us of the town's Jewish legacy. (Courtesy Rosalind Fischell.)

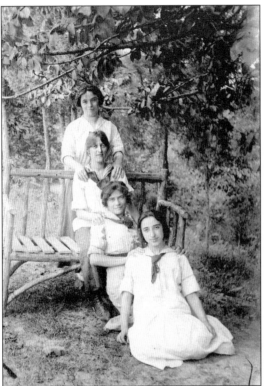

The Konner sisters Mollie (top) and Clara (bottom) are seen on the grounds of the Sunrise Hotel. (Courtesy Leslie Mund.)

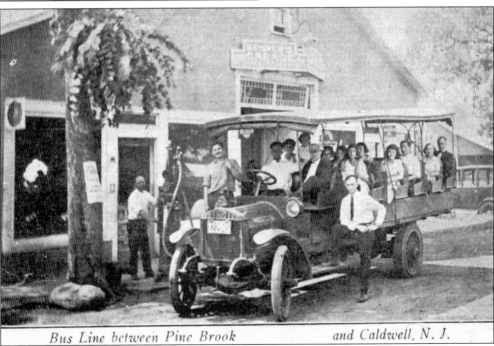

The Konner family established a shuttle omnibus service to take their guests from the train station in Caldwell to the Sunrise Hotel in Pine Brook. The bus service started in 1912. (Courtesy Leslie Mund.)

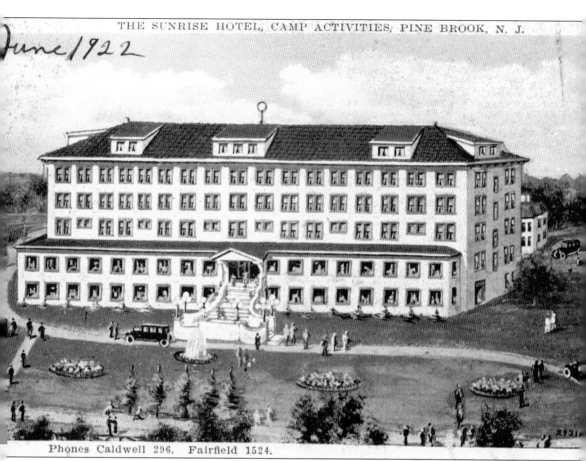

Lena and Josef Konner purchased 20 acres of farmland in Pine Brook in the early 1890s. Josef was not cut out to be a farmer. However, wife Lena's reputation as a good cook led to the start of Pine Brook's first kosher hotel, the Sunrise Mountain House, in 1904. The hotel burned but was replaced by another larger, more elegant hotel as featured in this postcard rendering. (Courtesy Leslie Mund.)

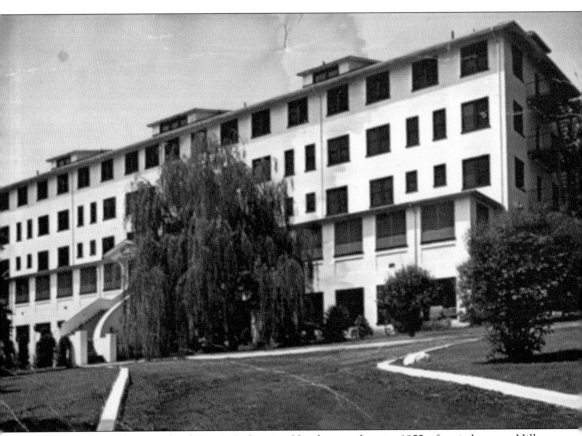

An actual photograph of Konner's Sunrise Hotel was taken in 1955 after it became Hilltop Nursing Home. Now deserted, this building was featured in the magazine *Weird New Jersey* in 1999. (Courtesy Leslie Mund.)

Jack Liebeskind married Mollie Konner. Jack owned a tavern on Old Bloomfield Avenue diagonally across the street from Pine Brook's synagogue. Congregants often parked their cars at the tavern lot so as not to be seen riding on the Sabbath or holidays. (Courtesy Leslie Mund.)

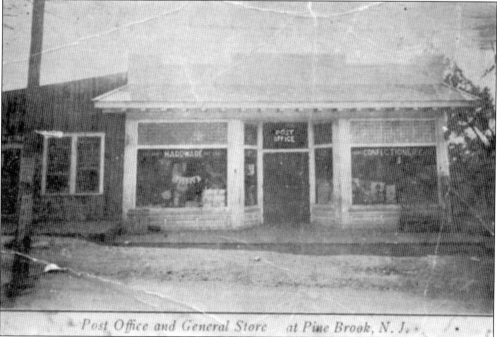

The building housing Pine Brook's post office in 1914 became Jack's Tavern, then the Town Tavern, and more recently, the site for Don Pepe's restaurant. (Courtesy Leslie Mund.)

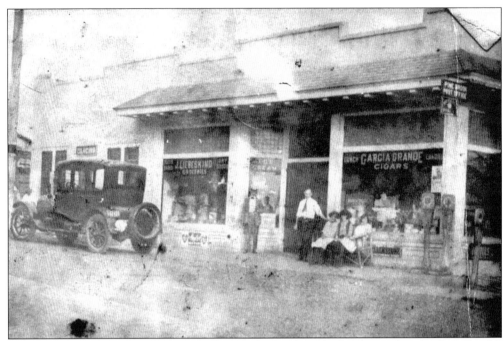

The left-side store window's lettering reads "J. Liebeskind." Liebeskind was related to Pine Brook's Konner family. (Courtesy Leslie Mund.)

Some 15 Jewish families met at the Konner hotel for religious services. At a birthday party for daughter Clara Konner on January 1, 1896, a decision was made to establish a formal synagogue. Josef Konner is supposed to have donated the land. This building opened in 1912, was renovated periodically over the years, and a new building, also located on Changebridge Road, opened in 1982. Pine Brook's Jewish Center merged with Lake Hiawatha Jewish Center in 1995. (Courtesy Jewish Historical Society of MetroWest Archives.)

The official name for Pine Brook's synagogue was Chevra Agudass Achim Anchy Pine Brook. This membership form, issued in the early 1900s, was written in Yiddish as were the congregation's original minutes ledgers. (Courtesy Jewish Historical Society of MetroWest Archives.)

Pine Brook's elementary school was named for its Jewish principal, Etta Coleman. (Courtesy Leslie Mund.)

Young Avron Coleman watched as workers dug the Pine Brook portion of Route 46 in 1939. (Courtesy Cyrene Aksman.)

Four generations of Bader farmers and family members have lived in this 100-year-old farm house located on Changebridge Road. A roadside stand adjacent to the farmhouse was established by Frances Bader in 1955. (Courtesy Jewish Historical Society of MetroWest Archives.)

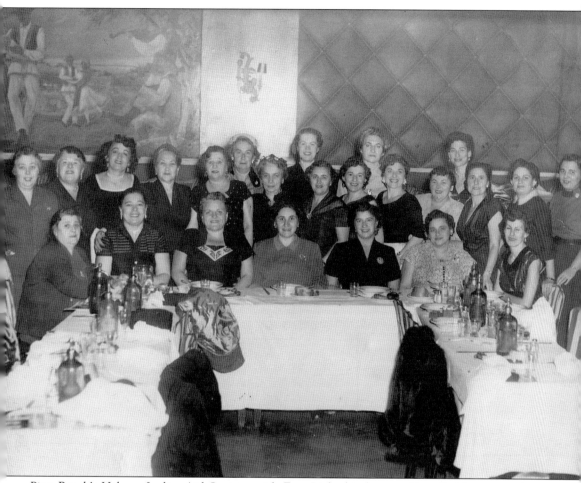

Pine Brook's Hebrew Ladies Aid Society, with Faye Liebeskind as president, held an annual donor dinner at the Old Roumanian restaurant in New York City in 1954. The women seated around the table are the "who's who" of the town's first Jewish settlers. (Courtesy Faye Liebeskind and Leslie Mund.)

A 1973 synagogue newsletter reveals a congregation in flux: its pre-school was meeting in a private home; the Hebrew school was meeting at the local elementary school; Adult Ed meetings were held in members' homes; sisterhood meetings were hosted at the Rockaway Neck First Aid Squad; Men's Club breakfasts at Cooper's Diner; and Sunday school at Rockaway Neck First Aid. At this time, a decision was made to build a larger, more modern synagogue. (Courtesy Jewish Historical Society of MetroWest Archives.)

Four

MOUNT FREEDOM
FAREWELL TO LITTLE BROADWAY

Max Levine and Yetta Steinberg Levine were Mount Freedom's first Jewish settlers. The couple purchased a dairy farm and moved to rural New Jersey from New York City's Lower East Side in 1903. The trip by horse and wagon took two days. The couple spent one night at the home of Morristown's Domb family before making the final leg of the journey up Sussex Turnpike. (Courtesy Yetta Steinberg Massarsky.)

Seated are brothers Julius (left) and Hyman Steinberg with children Yetta (left) and Herbert. They are on the grounds of sister Yetta Levine's farm located on Musiker Acres. (Courtesy Yetta Steinberg Massarsky.)

Phone Succasunna 107-M

Grand View Farm House

YETTA LEVIN, PROP.

First כשר Glass

SUMMER RESORT

Board by the Week. A Large Orchard With Fruits

Milk, Butter and Eggs Fresh Every Day. Fishing and Bathing

STOCK FARM Mt. Freedom, N. J.

Directions: Take Ferry to Hoboken, & Lackawanna Train to Morristown N. J. and from Morristown take Automobile direct to Mt. Freedom.

Send Packages to Morristown St. Kindly send notice 2 days before

Yetta Levin[e] promoted summer vacations at her Grand View Farm House and working farm to New York City residents. (Courtesy Arthur Regan.)

Isidor and Annie Saltz married in New York City in 1905. The couple purchased the Lanterman property and moved to Mount Freedom the same year. (Courtesy the Saltz family.)

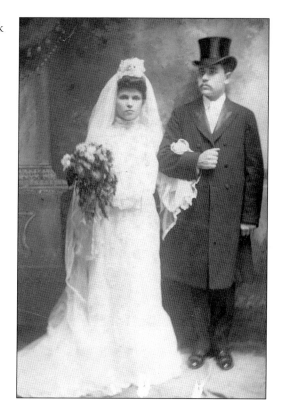

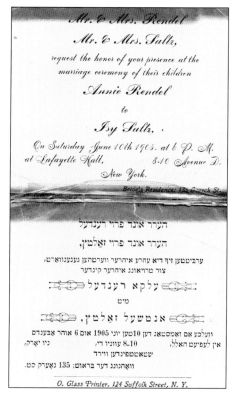

An invitation to the Saltz wedding, printed in English and Yiddish, reveals first generation Jewish immigrants had a foot in an old and new world. (Courtesy the Saltz family.)

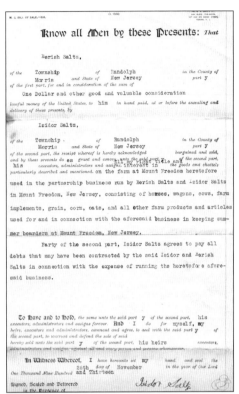

The deed for the sale of the Lanterman property to Isidor Saltz in 1905 included all "farming utensils, [live] stock, grain and mashing tools." The Saltz family grew what became the area's largest, full-service kosher hotel, Saltz Hotel, in operation through 1978. (Courtesy the Saltz family.)

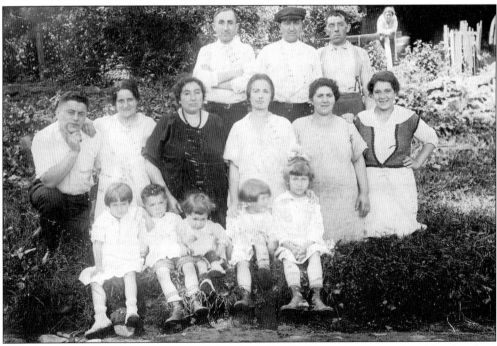

The Steinbergs were a large, boisterous, close-knit family. Sister Yetta encouraged her brothers and sisters to leave New York City and to settle in Mount Freedom so they could help her run her farm and boarding house. (Courtesy Arthur Regan.)

Hyman Steinberg and Annie Pampfel were the first Jewish couple married in Mount Freedom in 1911. (Courtesy Howard Steinberg.)

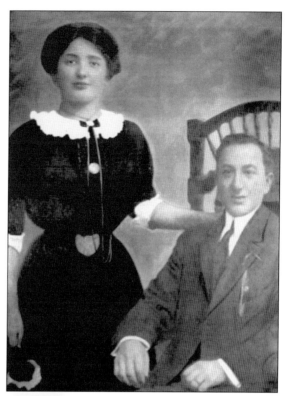

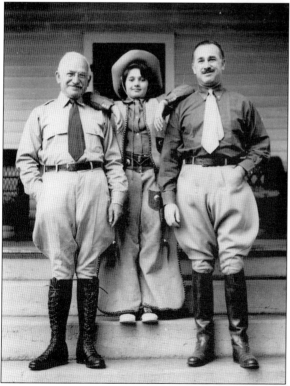

Successful New York City garment manufacturer Bernard Hirschhorn (left) purchased 100 acres in Mount Freedom in 1919. Hirschhorn owned Mount Freedom's first bungalow colony. He is featured with son, Herbert, and great niece, Carol Goodman. Upon retirement, Bernard acted as the town's honorary Justice of Peace. Herbert, an attorney in New York City, was synagogue president in the 1950s. (Courtesy Herbert H. Hirschhorn.)

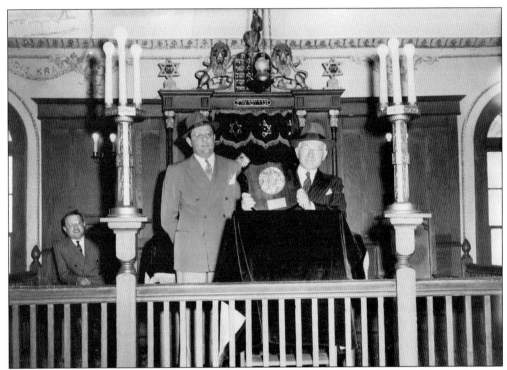

World War II veterans presented Bernard Hirschhorn an award of merit in the sanctuary of Hebrew Congregation of Mount Freedom in the late 1940s. Hirschhorn was a founding member of the synagogue in 1923. (Courtesy Shirley Kapner Rodin.)

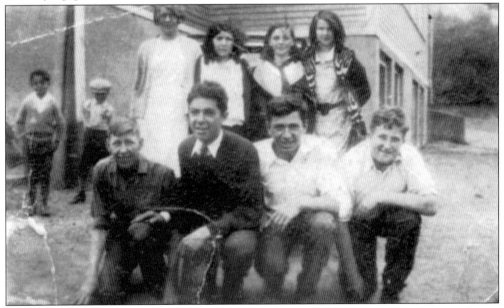

In the 1930s, Mount Freedom had a two-room schoolhouse divided into grades one through four and grades five through eight. Individual classes were small. Of the eight students in this 1928 class photograph, five were Jewish, including Pearl Zudick, Harold Regan, Shirley Kapner, Alfred Messer, and Yetta Steinberg. (Courtesy Shirley Kapner Rodin.)

Seen here is a class photograph taken in 1938. (Courtesy Shirley Kapner Rodin.)

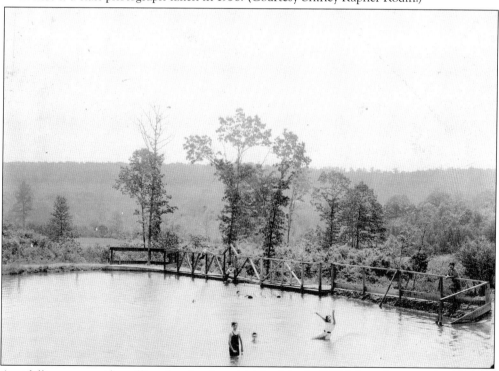

An idyllic countryside, rolling farmland, and high altitude (1,200 feet above sea level) made Mount Freedom a perfect summer resort. This lake was located on property owned by the Lieberman family. The lake was replaced by a hotel swimming pool. (Courtesy Madelyn and Charles Okun.)

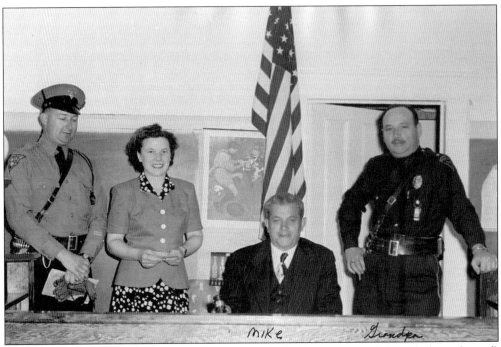
Various public offices were held by Jewish residents, including magistrate Mike Shulman (seated) court clerk Sadie Shulman, and police chief George Okun (right). (Courtesy Madelyn and Charles Okun.)

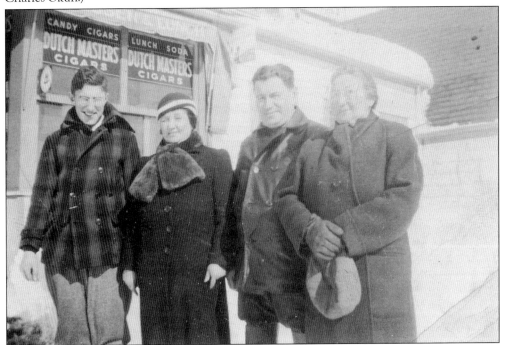
Local residents, from left to right, Arthur Regan, Annie Steinberg, Morris Regan, and Yetta Levine Pressman are in front of Steinberg's General Store on Main Road, or Sussex Turnpike. (Courtesy Arthur Regan.)

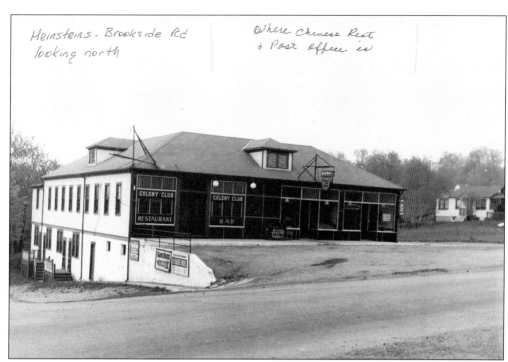

The retaining wall adjacent to Heistein's Colony Club, located on Sussex Turnpike, had directional arrows telling visitors to turn left to get to Saltz and Kessler Hotels. (Courtesy Madelyn and Charles Okun.)

Jewish residents Samuel Kapner and Eddie Kramer served with the volunteer fire department in the 1940s. (Courtesy Shirley Kapner Rodin.)

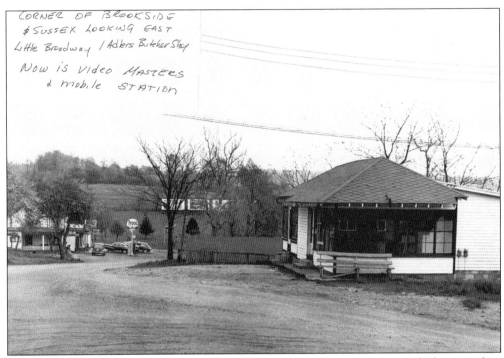

To the left is the building that housed Steinberg's combination restaurant, soda fountain, bar, gas station with one pump, and popular meeting spot, Little Broadway. To the right is Hymie Adler's kosher butcher shop. Adler would have been Morris County's only kosher butcher at one time. (Courtesy Madelyn and Charles Okun.)

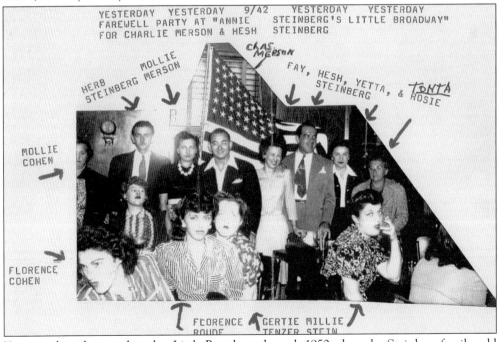

Year-round residents gathered at Little Broadway through 1950 when the Steinberg family sold the business. (Courtesy Yetta Steinberg Massarsky.)

Mount Freedom had one grocery store owned by the Skurnick family. (Courtesy Lisa Kaufman Greene.)

Morris Regan purchased Mount Freedom's schoolhouse and converted it in the 1920s to the building seen here. This became the residence for the synagogue's rabbis and was located next door to the synagogue. (Courtesy Arthur Regan.)

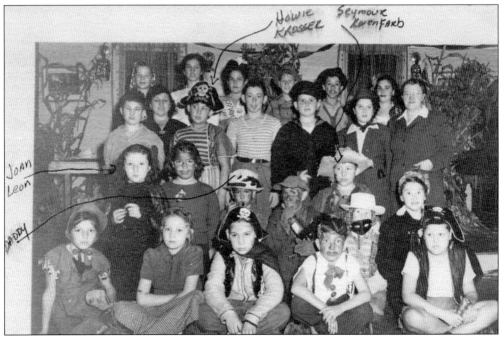

A second generation of Mount Freedom grade school children dressed for Halloween in 1947. (Courtesy Madelyn and Charles Okun.)

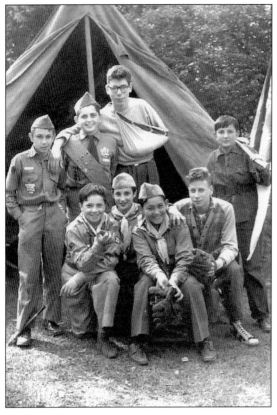

Boy Scout Troop 33, from left to right, is pictured around 1950 as follows: (first row) Chuck Zandell, Marty Epstein, Howie Krosser, and Ron Kramer; (second row) Bernie Finver, Jerry Selinfreund, Alan Bergle, and Mike Young. (Courtesy Madelyn and Charles Okun.)

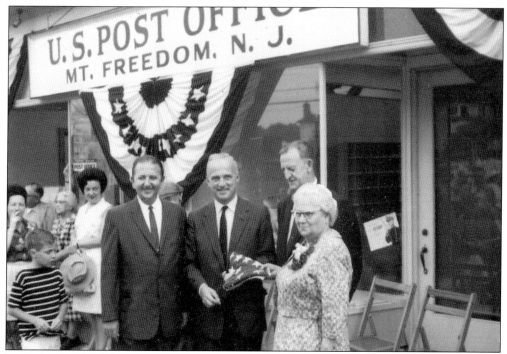

Jennie Kapner (right) received her appointment as postmistress from Pres. Franklin D. Roosevelt. Congressman Peter Frelinghuysen, holding the flag, and Kapner presided over the dedication of the town's new post office in 1963. (Courtesy Shirley Kapner Rodin.)

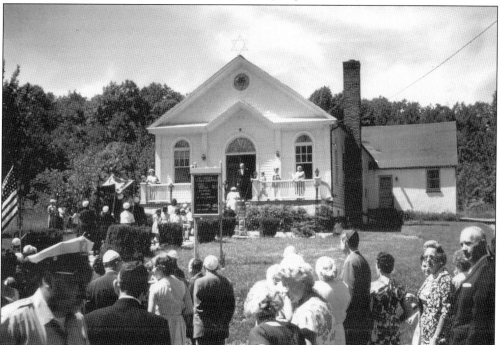

Hebrew Congregation of Mount Freedom dedicated its "Musiker Torah" on Memorial Day weekend in 1962. (Courtesy Arthur Regan.)

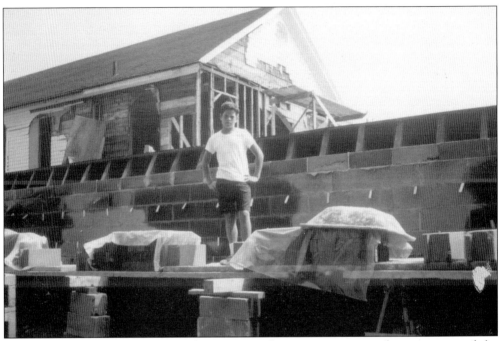

Sol and Toby Messer's son, Howard, is seen on the construction site for renovation of the synagogue in the early 1960s. The Messer family owned a hotel at Harbor Hills that later became a summer camp. Sol Messer was the town's first Jewish mayor. Howard became president of Mount Freedom Jewish Center. (Courtesy Arthur Regan.)

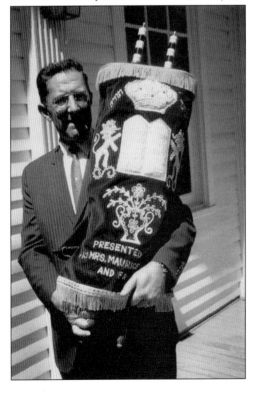

One-time resident Arthur Regan is seen holding the Torah that was dedicated in 1962. (Courtesy Arthur Regan.)

Hebrew Congregation of Mount Freedom, in 1923, was a small, white clapboard building consisting primarily of a sanctuary. When the building was renovated, care was taken to incorporate the original sanctuary by building around the exterior walls. The clapboards of the first synagogue can be seen by lifting a stained glass window located in the lobby of the synagogue. (Courtesy Jewish Historical Society of MetroWest Archives.)

תשי"ט
1958-5719

Nº 49

לשנה טובה תכתבו
לשמוע אל הרנה ואל התפלה

Hebrew Congregation of Mt. Freedom
MAIN STREET, MT. FREEDOM, N. J.

RABBI SAMUEL LIEBERMAN WILL OFFICIATE

ROSH HASHONAH	KOL NIDRE NIGHT	YOM KIPPUR
ראש השנה	כל נדרי	יום כפור
Sept. 15-16	September 23	September 24

Membership - Price $5.00

Congregants received tickets for admission to High Holiday services. Initially, holiday services were held in the banquet rooms of the town's hotels. (Courtesy Mount Freedom Jewish Center.)

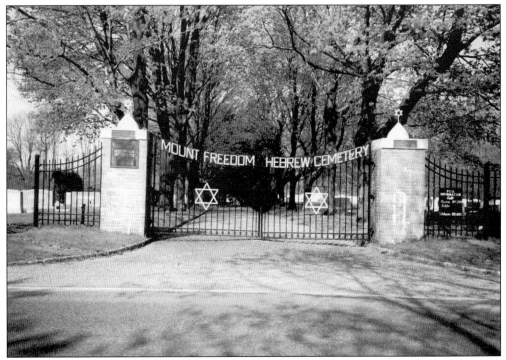

Mount Freedom Hebrew Cemetery was founded in 1937. Founding committee members were Sol Roude, Morris Zudick, Isidor Saltz, Bernard Hirschhorn, Herbert Hirschhorn, and Nathan Kemelson. (Courtesy Jewish Historical Society of MetroWest Archives.)

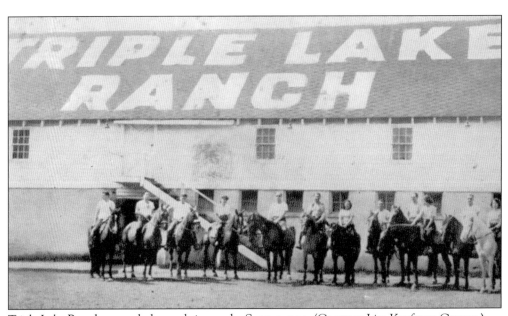

Triple Lake Ranch was a dude ranch in nearby Succasunna. (Courtesy Lisa Kaufman Greene.)

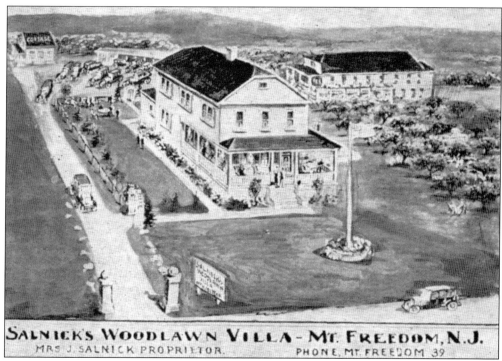

A rare postcard image of Salnick's Woodlawn Villa prompted long-time resident Sol Messer to recall that Jennie Salnick was the resort area's best cook. (Courtesy Lisa Kaufman Greene.)

From left to right, Leon "Pete", Dave, Harriet, and Pauline Lieberman were owner's of Lieberman's Hotel from the 1930s through the 1950s. Pauline Lieberman was a sister to owners of Saltz Hotel. (Courtesy Madelyn and Charles Okun.)

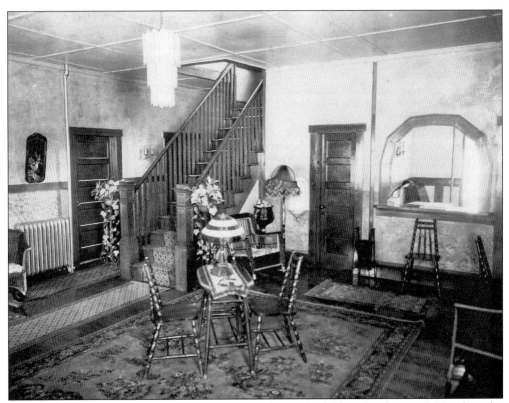
One of nine Jewish owned and operated hotels, this is the lobby of Lieberman's Hotel in the 1930s. (Courtesy Madelyn and Charles Okun.)

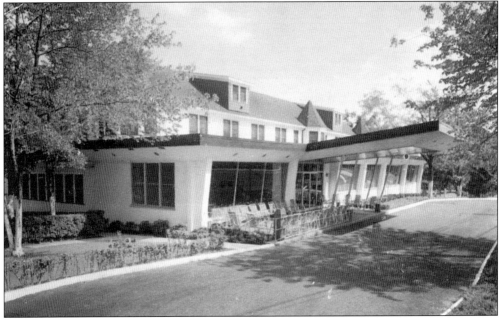
Hotel owners were obligated to modernize their facilities. This is the renovated entrance to Lieberman's Hotel in 1950. (Courtesy Madelyn and Charles Okun.)

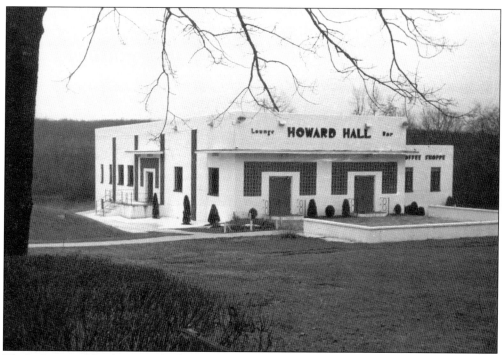

The Lieberman Hotel campus had a separate nightclub called Howard Hall. (Courtesy Madelyn and Charles Okun.)

Phone Succasunna 107-M Mt. Freedom, N. J.

The Grand View

L. SAINS, PROP.

Strictly כשר Kosher

An Ideal Resort for Vacationists Dairy and Vegetable Products from our own Farm

Bathing - Fishing - Dancing - Tennis Courts

Directions: Take Ferry to Hoboken and Lackawanna Train to Morristown, N. J. and from Morristown take Automobile direct to Mt. Freedom. Send baggage to Morristown Station. Kindly notify 3 days before leaving.

Yetta Levine sold her boarding house and property to Louis and Eva Sains in 1929. Initially Sains kept the Grand View name. (Courtesy Arthur Regan.)

By 1950, Sains Hotel established a reputation as the town's second largest hotel. (Courtesy Leonard I. Sains.)

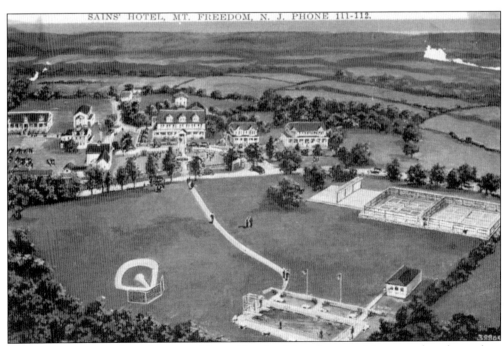

There are scant records to document Mount Freedom's hotel resorts. Most were lost, burned, or thrown away. A Sains Hotel postcard featuring tennis courts, guest houses, baseball field, and swimming pool are reminiscent of a prosperous hotel resort era. (Courtesy Leonard I. Sains.)

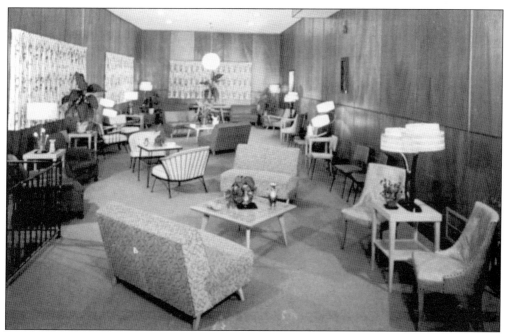
The lobby of Sains Hotel sports a 1950s decor. (Courtesy Leonard I. Sains.)

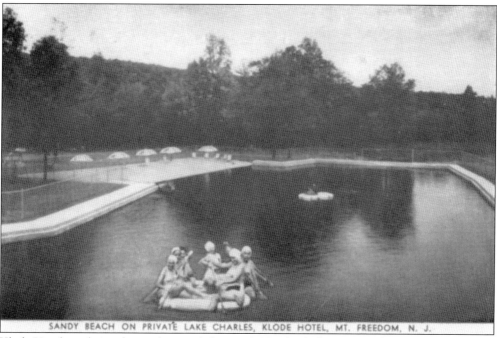
Klode Hotel was located next door to Ackerman's Hotel. Klode was a modest-sized hotel. It, like all the hotels, had regular nightly entertainment. MetroWest residents Howard Kiesel and Joe Horowitz played in the band. (Courtesy Lisa Kaufman Greene.)

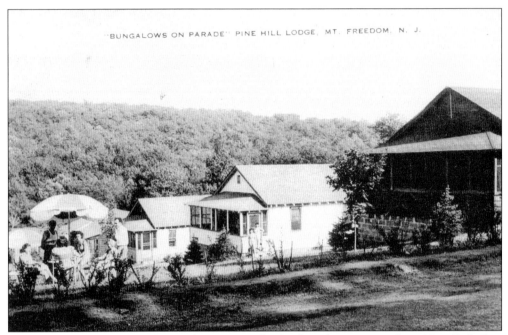

Pine Hill Lodge was where the singles met. Bus loads of singles came out from New York City on a Friday evening and returned the following Sunday. Those who arrived by car parked in a nearby cow pasture. (Courtesy Lisa Kaufman Greene.)

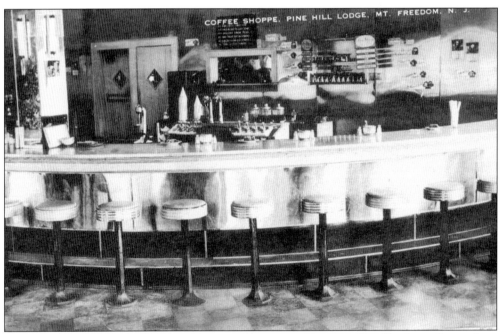

The coffee shop at Pine Hill Lodge was a sociable setting. (Courtesy Lisa Kaufman Greene.)

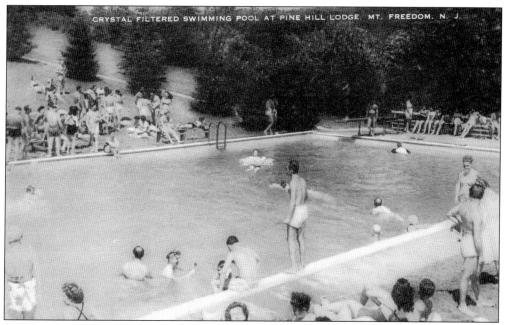

Local resident Edward Cohn recalled putting on a diving exhibition to attract the attention of the girls around the Pine Hill Lodge pool. (Courtesy Lisa Kaufman Greene.)

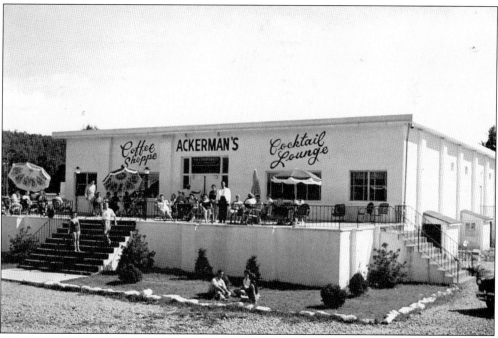

The dining room at Ackerman's Hotel, now home to Randolph Township's Public Library, is all that is left to remind local residents of the town's one-time thriving resort hotel industry from the 1920s through the 1960s. (Courtesy Lisa Kaufman Greene.)

There were as many as 45 bungalow colonies identified on a Randolph Township map by MetroWest resident Stanley Saltz. A copy of the map is in the Jewish Historical Society of MetroWest Archives and the Randolph Museum. (Courtesy Randolph Museum.)

As town residents living on Farview Road, one had use of the facilities at nearby Bungalow Acres. Lisa Kaufman Greene attended Bungalow Acres Day Camp in 1961. (Courtesy Lisa Kaufman Greene.)

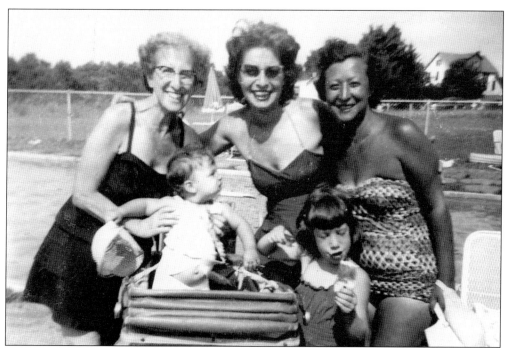
Standing from left to right are Gussie Popick, owner of Popick's Bungalows (1944–1963), Selma Popick Blumenthal, and unidentified, with children Nancy (left) and Donna Blumenthal. (Courtesy Nancy Engel.)

The pool at Popick's Bungalows is pictured in 1960 with Donna (left) and Nancy Blumenthal. Popick's was located on Calais Road. (Courtesy Nancy Engel.)

Shirley Kapner Rodin and Sherman Kapner attended the exhibit "Jewish Life in Mount Freedom." Sherman recalls his bar mitzvah reception that was held in the small entrance room that led to the synagogue sanctuary. Shirley recalls meeting her husband at one of the hotels. (Courtesy Jewish Historical Society of MetroWest Archives.)

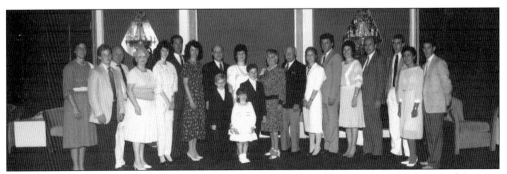

The Saltz family is seen here at a family bar mitzvah in 1985. (Courtesy Jewish Historical Society of MetroWest Archives.)

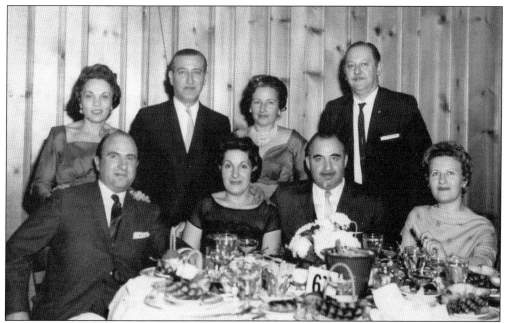

The Zudick, Herman, and Wasserman families, associated with the founding and building of Hebrew Congregation of Mount Freedom, were also active at Morristown's Jewish Center. Morris Zudick was a successful Morris County builder. (Courtesy Jewish Historical Society of MetroWest Archives.)

Rosie Steinberg and Julius Steinberg helped operate Yetta Levine's Grand View farm and boarding house. From left to right, Steinberg family members included (first row) Rosie Steinberg, Julius Steinberg, Florence Shimmel, Yetta Massarsky, Asher Massarsky, Arnold Milkman, and Marlene Milkman; (second row) Robert Shimmel, Fay Steinberg, Hesh Steinberg, and Irwin Wasserman. They were guests at the wedding of Linda and Lou Koval. (Courtesy Jewish Historical Society of MetroWest Archives.)

Vera and Herbert Steinberg's parents owned and operated the town's gathering place, Little Broadway. Seen here, from left to right, are (first row) Florence Okun, Bernie Saltz, Ruth Bergle, Irene Steinberg, and Pearl Silverberg; (second row) Vera Steinberg, Herbert Steinberg, Mel Steinberg, and Joe Silverberg. (Courtesy Jewish Historical Society of MetroWest Archives.)

Leon "Pete" Lieberman is reputed to have held an audition for what was described as "a skinny kid," and told the singer whose name was Frank Sinatra, "kid, you got no talent." Guests, from left to right, are (first row) Helen and Joseph Lieberman, Helen and Harry Stein, and Harriet and Pete Lieberman; (second row) Jack and Millie Goodman, George and Ida Okun, and Frank and Toby Lasker. (Courtesy Jewish Historical Society of MetroWest Archives.)

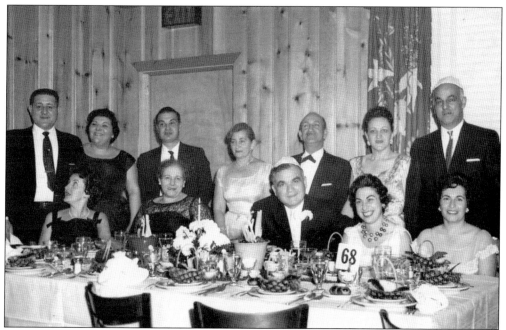

Sol Messer, standing far right, was the town's first Jewish mayor in the 1950s. Sol and wife Toby, seated far right, owned Harbor Hills Hotel, which became a summer camp. Gloria and Iz Gargle, standing second and third from left, owned Pine Hill Lodge. (Courtesy Jewish Historical Society of MetroWest Archives.)

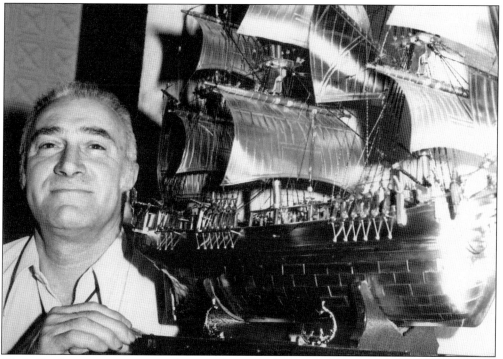

Edwin Kaufman was a master craftsman who made ships out of copper. Many were exhibited in area museums and libraries. (Courtesy Lisa Kaufman Greene.)

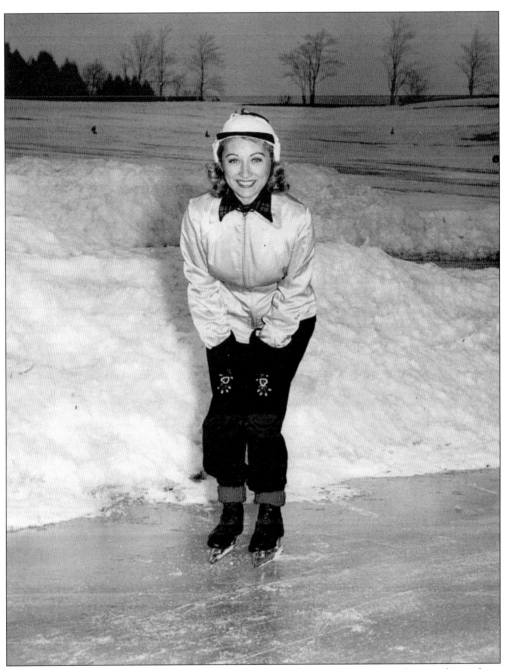
Rose Hirschhorn, wife of Herbert H. Hirschhorn, whose parents owned a working farm and a bungalow colony, is seen ice-skating on one of the small lakes that dotted the surrounding Mount Freedom countryside in the 1940s. (Courtesy Jewish Historical Society of MetroWest Archives.)

Five

AFTER THE WAR
SYNAGOGUES AND LAKE COMMUNITIES

Temple B'nai Or, located on South Street in Morristown, was dedicated in 1958 on land donated by former Mayor W. Parsons Todd. Mayor Todd is fifth from the right. (Courtesy Temple B'nai Or.)

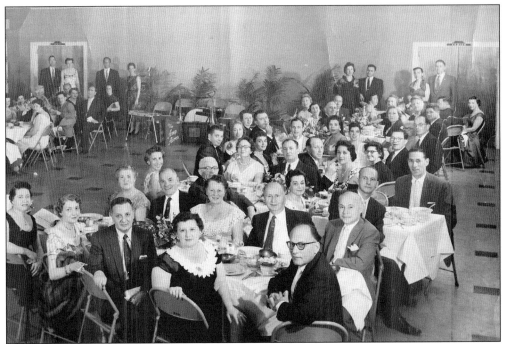

Temple B'nai Or hosted its first Journal Dinner Dance at Mazdabrook Farms in May 1956. Many of the faces in the crowd were former members of the Jewish Community Center of Morristown. (Courtesy Jewish Historical Society of MetroWest Archives.)

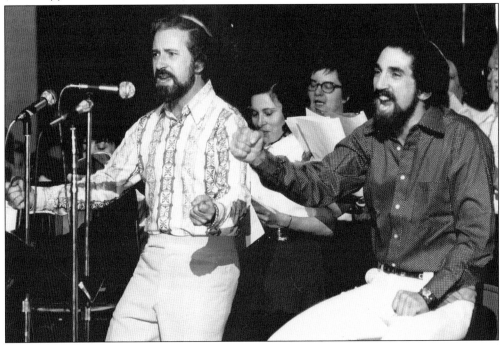

Rabbi Z. David Levy (left) appeared in concert with cantor Ted Aronson in 1980. Levy, a social activist who served the congregation from 1962 to 1990, introduced contemporary music to Temple B'nai Or services. (Courtesy Jewish Historical Society of MetroWest Archives.)

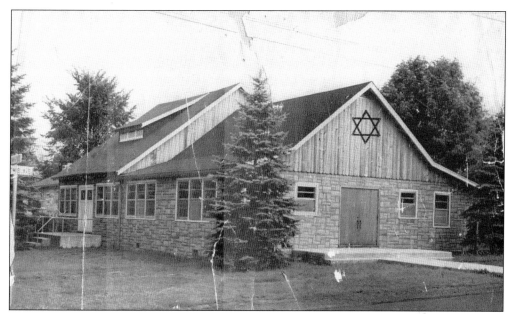

A wooden building on the corner of Nokomis Avenue and Hiawatha Boulevard served as Lake Hiawatha's first synagogue in 1946. Dr. Herman Minzesheimer was elected first president. The site is the current home of the town's public library. (Courtesy Helen Stiel Schraeger.)

Congregants Morris and Sadie Wishnick (right) enjoyed the Torah ark curtain created by Renee Savitz, wife of Lake Hiawatha Jewish Center's Rabbi Herman Savitz, in honor of the Wishnick's 50th wedding anniversary. (Courtesy Renee and Rabbi Herman Savitz.)

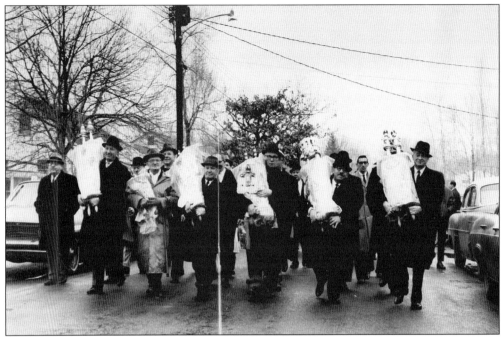

On a cold, rainy February day in 1964, joyful congregants marched with their Torahs along Lake Hiawatha's Lake Shore Drive to their new synagogue building located on Lincoln Avenue. (Courtesy Arlene Benowitz.)

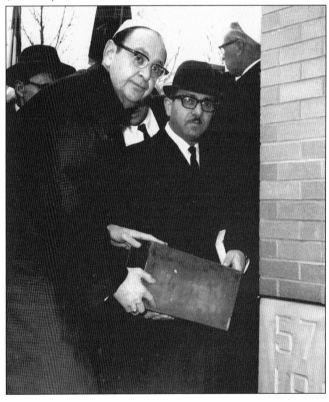

Pres. Monroe Saul (left) and Rabbi Zdanowitz set the cornerstone in the new Lake Hiawatha Jewish Center. (Courtesy Arlene Benowitz.)

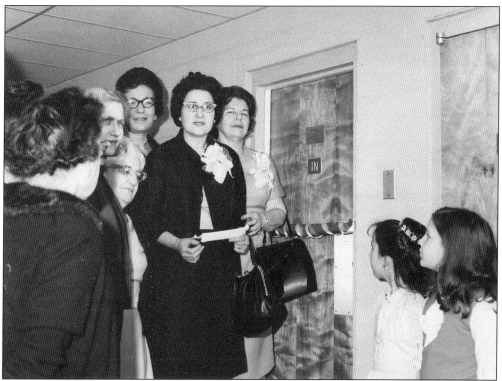

Members of Lake Hiawatha's sisterhood, including Miriam Cohen (center), cut the ribbon at a dedication ceremony for the synagogue's new kitchen. (Courtesy Arlene Benowitz.)

Lake Hiawatha, dug in 1933, was created by erecting a dam across the Rockaway River. It was more a swimming pool than a lake. Plagued by outbreaks of algae and undergrowth, the lake was drained in 1960 and a swimming pool was put in its place. (Courtesy Helane Ullman.)

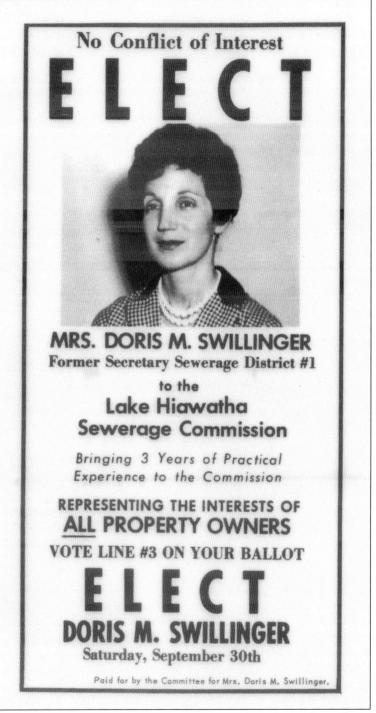

Attracted by affordable vacation homes, a host of New York City Jewish residents winterized their summer homes and stayed year-round. Many devoted time to civic activities, including Doris Swillinger, who ran and was elected the town's sewage commissioner in 1953. (Courtesy Dan Swillinger and Helane Ullman.)

Promoted as just 55 miles from New York City, developer Benjamin J. Kline convinced New York City residents to purchase summer homes at White Meadow Lake immediately following World War II. (Courtesy White Meadow Temple.)

You are cordially invited to attend a
Brotherhood Service and Program
jointly sponsored in fellowship by
The First Methodist Church
The First Presbyterian Church
White Meadow Temple
Rockaway, N. J.
at White Meadow Temple
Sunday Evening, February 18, 1962
at 7:45 o'clock

White Meadow Temple's Rabbi Jacob Weitman, realizing the concern of local Rockaway residents toward an influx of Jews to the area, sought to educate neighboring gentiles about Jewish traditions and customs as a way to establish lines of communication between the two groups. (Courtesy White Meadow Temple.)

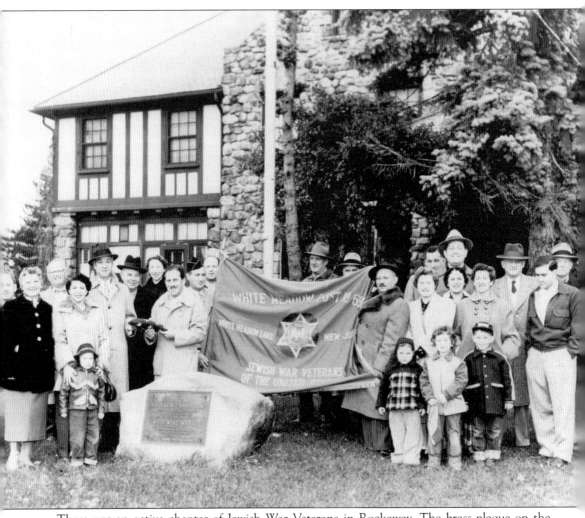

There was an active chapter of Jewish War Veterans in Rockaway. The brass plaque on the rock in this photograph reads, "This plaque is dedicated to Benjamin J. Kline, Morton Kline, and Norman Kline for their role in developing White Meadow Lake." (Courtesy White Meadow Temple.)

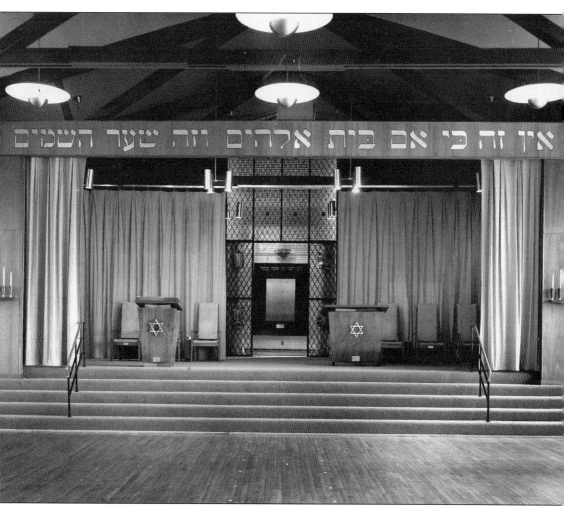
White Meadow Temple, incorporated in 1952, built its first synagogue building in the tradition of a "country shul." This is the sanctuary in 1955. (Courtesy the Silvershein family.)

Rabbi Jacob Weitman (center) arrived in 1955. He is featured with the first bat mitzvah class in 1958. Weitman was the spiritual leader and guiding force in growing White Meadow Temple until his retirement in 1989. (Courtesy White Meadow Temple.)

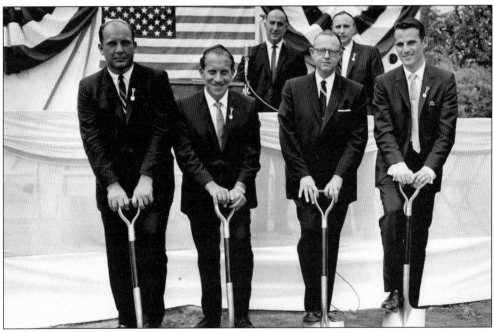

Opened in 1952, White Meadow Temple's growing membership led to a 1964 ground-breaking ceremony for renovations and additions to the building featuring, from left to right, Ken Freedman, Irving Rifkin, Rabbi Jacob Weitman, and Bennett Silvershein. (Courtesy Jewish Historical Society of MetroWest Archives.)

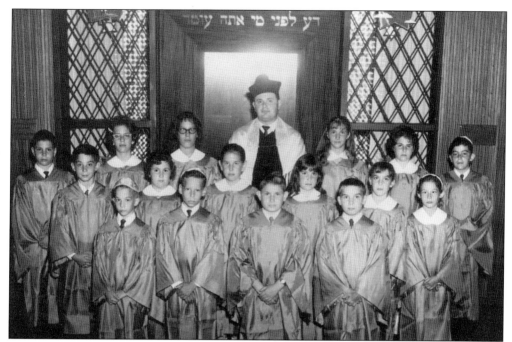

Cantor Burstein is seen here with a White Meadow Temple Hebrew school class in the 1950s. (Courtesy Jewish Historical Society of MetroWest Archives.)

Martha Silvershein (left), considered to be the founding mother of White Meadow Temple, is featured with First Lady Eleanor Roosevelt in 1956. Roosevelt was a regular speaker at events in the greater Morris County Jewish community. (Courtesy Marilyn and Bennett Silvershein.)

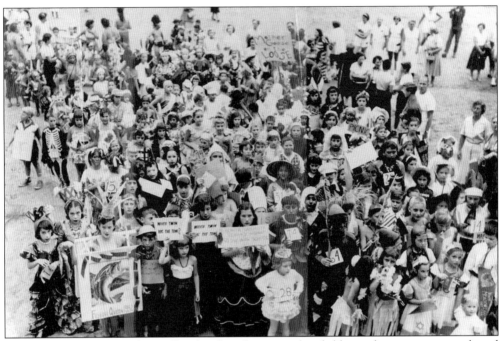

Developer Benjamin J. Kline offered a free day camp for children whose parents purchased one of his homes that surrounded White Meadow Lake. As many as 300 Jewish families were summer residents starting in the late 1940s and early 1950s. (Courtesy Jewish Historical Society of MetroWest Archives.)

ROXBURY REFORM TEMPLE

CORDIALLY INVITES YOU TO ATTEND

OUR FIRST FRIDAY NIGHT SERVICE

AT THE

FRANKLIN SCHOOL

MEEKER STREET, SUCCASUNNA

SEPTEMBER 9TH. AT 8:30 P. M.

RABBI BERNARD GOLDSMITH OFICIATING

ONEG SHABBAT TO FOLLOW

The first Sabbath services conducted by fledgling Roxbury Reform Temple were held in a Succasunna elementary school in 1960. (Courtesy Dr. Edward and Florence Gates.)

A sign announcing the future home of Roxbury Reform Temple is flanked by founding members, from left to right, Dr. Edward, Florence Gates, and Norman and Sophie Goldblatt. Gates organized the effort to purchase land for the proposed synagogue. (Courtesy Dr. Edward and Florence Gates.)

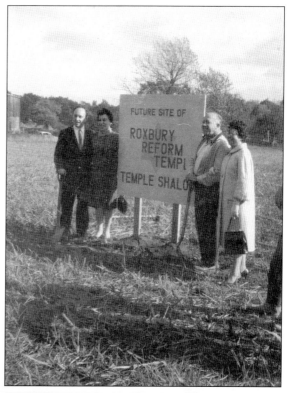

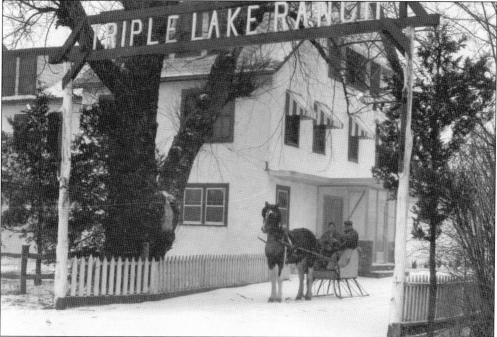

While waiting for their synagogue building to be completed, congregants of Roxbury Reform Temple held High Holiday services in the banquet room of nearby Triple Lake Ranch. (Courtesy Jewish Historical Society of MetroWest Archives.)

Roxbury Reform Temple changed its name to Temple Shalom of Succasunna. This is the temple's first modest sanctuary, complete with folding chairs in the 1960s. (Courtesy Dr. Edward and Florence Gates.)

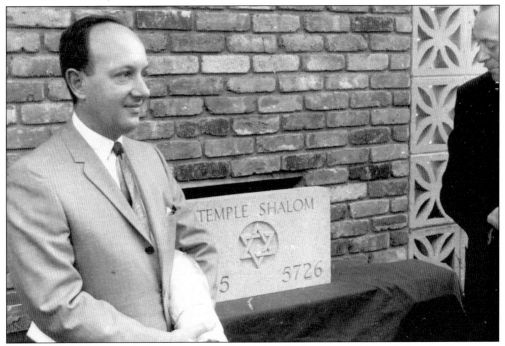

Synagogue founder and first president Dr. Edward Gates participated in the laying of the cornerstone for Temple Shalom of Succasunna in 1965. (Courtesy Dr. Edward and Florence Gates.)

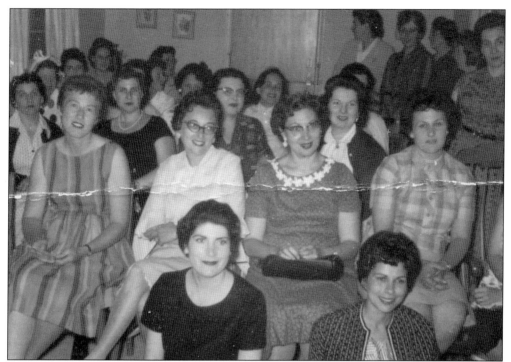

The earliest sisterhood meetings for Temple Shalom of Succasunna were held at member homes, including this meeting at the home of Florence Gates around 1960. (Courtesy Dr. Edward and Florence Gates.)

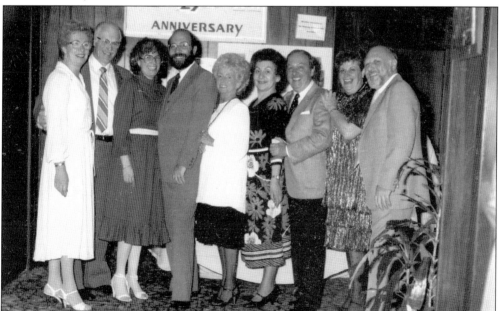

A 25-year anniversary and cause for celebration, brings together Temple Shalom of Succasunna's founding families (left to right) Sheri and Harvey Boronson, Rabbi Joel and Sandy Soffin, Tillie Kamm, Florence and Edward Gates, and Doris and Bill Forst. (Courtesy Jewish Historical Society of MetroWest Archives.)

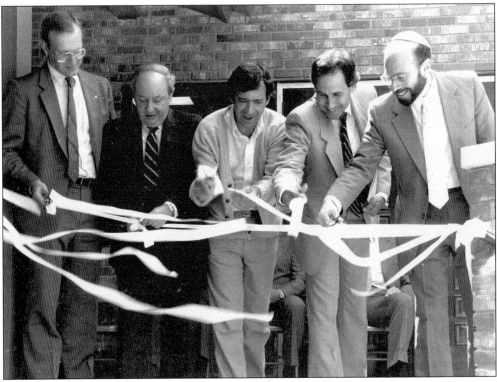

A ribbon-cutting ceremony marked the expansion of Temple Shalom in the 1980s. (Courtesy Dr. Edward and Florence Gates.)

 To symbolize this household's commitment to the prevention of nuclear war and to seeking world peace, we have proclaimed our home to be a **PEACE SITE**

name date

From the outset, Temple Shalom of Succasunna's members were involved in all types of social action. The temple was one of New Jersey's 22 designated peace sites opposed to a world-wide nuclear threat. (Courtesy Jewish Historical Society of MetroWest Archives.)

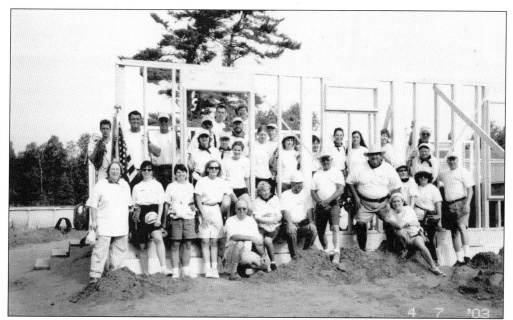

"Build we must" is the caption for this photograph showing Temple Shalom of Succasunna members participating in a partnership with Habitat for Humanity and a Reform Judaism Adult Mitzvah Corporation build in Burlington, Vermont. (Courtesy Belle Schwartz.)

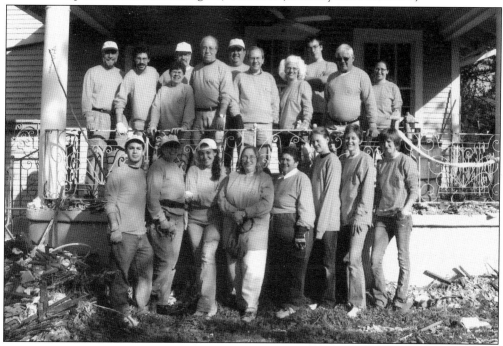

This photograph documents social action at its best. Responding to the crisis caused by hurricane Katrina in New Orleans in 2005, members of Temple Shalom of Succasunna traveled to Louisiana to participate in a Reform Judaism Adult Mitzvah Corporation project. The idea of participating in the builds came from the congregation's rabbi emeritus Joel Soffin (second row, left) and congregant Stuart Bauer (second row, fifth from left). (Courtesy Shirley and Stuart Bauer.)

Sam Golub, founder of Mount Olive Jewish Center, or Temple Hatikvah located in Flanders, posted a sign in a local supermarket in 1969 requesting area Jewish families to attend a meeting for the purpose of establishing a synagogue in the Budd Lake area. (Courtesy Jewish Historical Society of MetroWest Archives.)

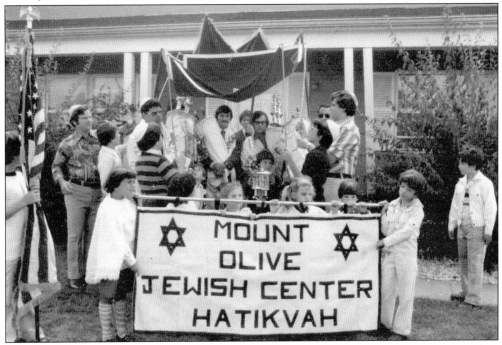

A Torah procession to dedicate the opening of Temple Hativah started in front of founding member Alan Cohen's home in 1977. New Jersey's Governor Brendan Bryne flew in by helicopter to attend the dedication ceremonies. (Courtesy Temple Hatikvah.)

The sanctuary of Congregation Shaya Ahavat Torah, Morris County's oldest Orthodox synagogue in 1974, shows the *mechitzah*, or wall separating men and women during prayer services. (Courtesy Jewish Historical Society of MetroWest Archives.)

Congregation Beth Torah, originally Suburban Center of Congregation AABC, an outgrowth of an Irvington synagogue, held its first exploratory meeting at the home of Bernice and Jack Spiegelman in 1979. The synagogue is located in Florham Park. (Courtesy Jewish Historical Society of MetroWest Archives.)

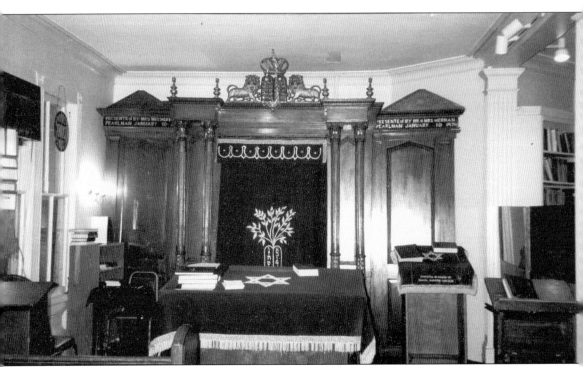
Approximately 25 Orthodox families broke from Morristown Jewish Center in 1980 and established Congregation Ahavath Torah. This is the synagogue sanctuary. (Courtesy Jewish Historical Society of MetroWest Archives.)

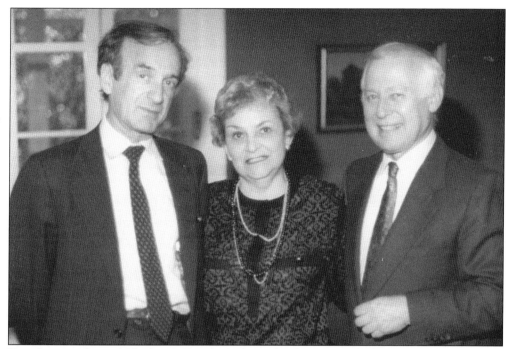
Founding members of Chatham's Temple Beth Hatikvah in 1994, Shirley (center) and Bob Max (right), met with renowned Nobel Peace Prize winner Elie Wiesel. (Courtesy Shirley and Robert R. Max.)

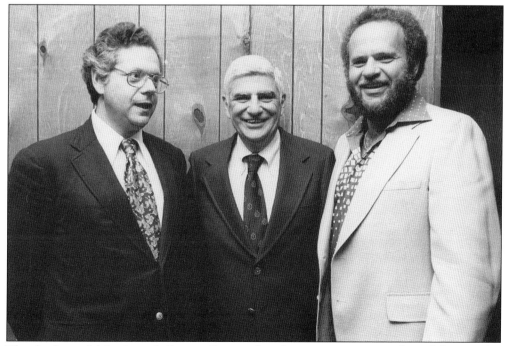
The leaders of Morris and Sussex County Jewish communities are, from left to right, Sanford Hollander, Daniel Drench, and Ralph Stern. (Courtesy Jewish Historical Society of MetroWest Archives.)

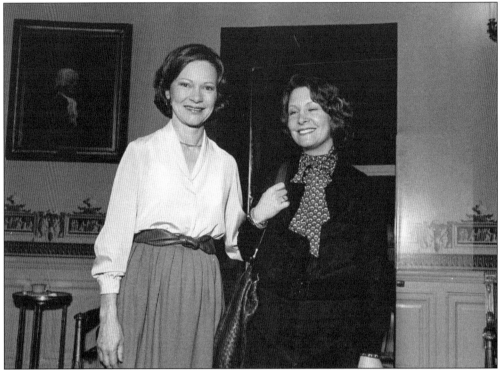

MetroWest resident Charlotte Turner (right) met with First Lady Rosalynn Carter at the White House in 1979. (Courtesy Jewish Historical Society of MetroWest Archives.)

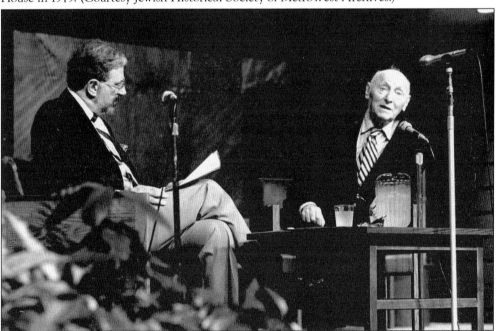

Morris County synagogues continue to host scholars-in-residence. Distinguished author and Nobel Laureate Isaac Bashevis Singer (right) was interviewed by Temple B'nai Or's Rabbi Z. David Levy in 1980. (Courtesy Jewish Historical Society of MetroWest Archives.)

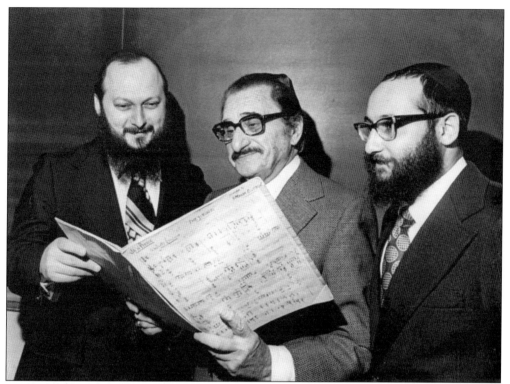

Famed Metropolitan Opera tenor Jan Peerce (center) is discussing his concert selections with dean of Rabbinical College of America Rabbi Moshe Herson (left) and Rabbi Teitelbaum, concert coordinator in 1976. (Courtesy Jewish Historical Society of MetroWest Archives.)

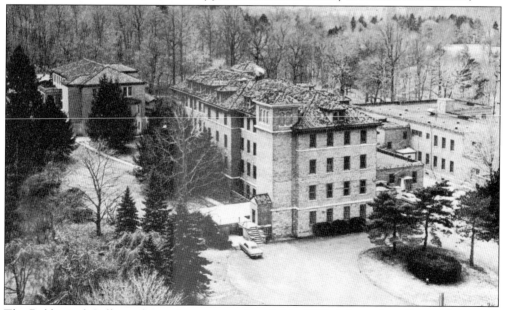

The Rabbinical College of America campus, founded in 1954, is located on Sussex Avenue in Morristown since 1971. The college purchased 66 acres from World War II Marine Col. Ruth Cheney Streeter. (Courtesy Jewish Historical Society of MetroWest Archives.)

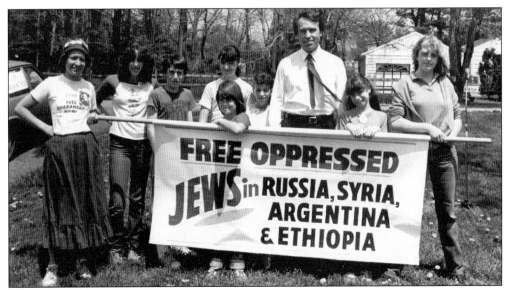

Morris County's Jewish community has a long-standing tradition of social action and providing social services to American and world-Jewry. Morris County's one-time congressman James Courter lent his support to Jewish causes. (Courtesy Jewish Historical Society of MetroWest Archives.)

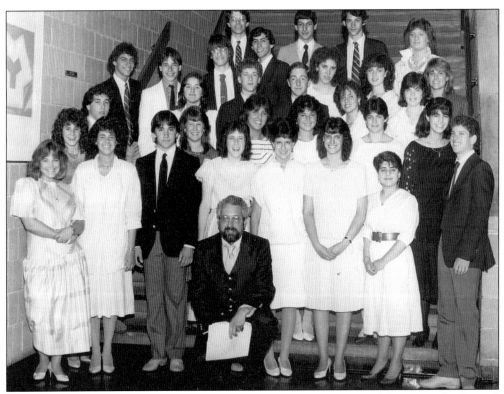

Teens are encouraged to continue their religious studies post bar and bat mitzvah. Central Hebrew High School graduates are featured with principal Rabbi Stu Warner (seated, center). (Courtesy Jewish Historical Society of MetroWest Archives.)

COMMITTEE FOR THE ORGANIZATION OF A HEBREW DAY SCHOOL IN MORRIS COUNTY

COMMITTEE IN FORMATION
Rabbi Abba Abrams
Emanuel Auerbach, Ph.D.
Cantor Irving Burstein
Jack H. Domash
Nathan Ehrlich
Thomas L. Hausdorff
Bernard Manischewitz
Rabbi Irving H. Perlman
Rabbi Jerome Pruzanski
Cantor Arthur Sacks
Paul S. Strauss, Ph.D.
Judge Herbert Strulowitz
Dr. Alvin J. Turner
Rabbi Jacob Weitman
Dr. Morton L. Wertheimer
Rabbi Abraham Zdanowitz

January 12th, 1967

Dear Friend:

It is our wish to start a Hebrew Day School in Morris County.

The objectives of this school will be to give its students a good background and education in Jewish culture, language and tradition and a superior English secular education.

To this purpose, we would like to invite you to attend a General Meeting at the Morristown Jewish Community Center on Tuesday, January 31st, 1967 at 8:00 p.m.

Information regarding all aspects of the school will be available and discussed.

It is our pleasure and wish that we see you at this meeting.

Sincerely,

Dr. Alvin J. Turner

AJT/mab

For further information contact your Rabbi.
Please return enclosed postal card.

A committee to establish a Jewish day school in Morris County got underway in 1967. Up to this time, Jewish children attended day schools in Essex, Passaic, and Bergen Counties, often commuting great distances to these schools. (Courtesy Rabbi Jacob Weitman.)

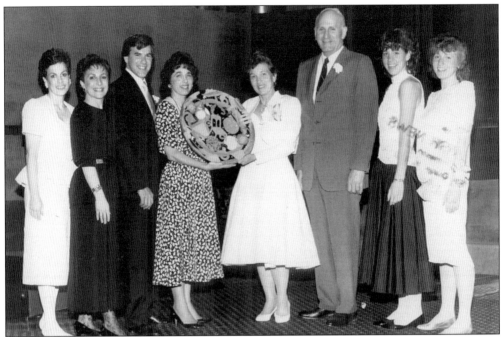

Paula and Jerome Gottesman, fifth and sixth from left, accepted a token of appreciation presented on behalf of Bohrer-Kaufman Hebrew Academy of Morris County from former president of the Morris-Sussex Jewish Federation, Judy May. The Gottesmans are significant benefactors of Jewish day school education in Morris County. From left to right are Helen Schwartz, Cynthia Geller, Dr. Steven Schwartz, Judy May, Paula Gottesman, Jerome Gottesman, and Marjorie and Abbie Gottesman in 1987. (Courtesy Jewish Historical Society of MetroWest Archives.)

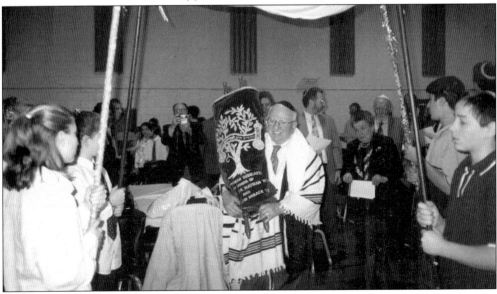

Dedicating the Torah to the Hebrew Academy of Morris County, located in Randolph since 1980, is benefactor Horace Bier, who, with Dr. Morton Werthheimer, Dr. Alvin Turner, and Michael Rubenstein, spearheaded the fund-raising to establish Morris County's only Jewish day school. (Courtesy Hebrew Academy of Morris County.)

Kim Hirsh, doing research in the offices of the Jewish Historical Society of MetroWest, is a parent of three Hebrew Academy of Morris County day school students. Hirsh is responsible for gathering and donating historical records of the Hebrew Academy for preservation in the community's archives. (Courtesy Jewish Historical Society of MetroWest Archives.)

Kindergarten through eighth grade students, teachers, the principal, and office staff at Hebrew Academy of Morris County are featured in this 2002 photograph. (Courtesy Hebrew Academy of Morris County.)

Discover Thousands of Local History Books Featuring Millions of Vintage Images

Arcadia Publishing, the leading local history publisher in the United States, is committed to making history accessible and meaningful through publishing books that celebrate and preserve the heritage of America's people and places.

Find more books like this at
www.arcadiapublishing.com

Search for your hometown history, your old stomping grounds, and even your favorite sports team.

Consistent with our mission to preserve history on a local level, this book was printed in South Carolina on American-made paper and manufactured entirely in the United States. Products carrying the accredited Forest Stewardship Council (FSC) label are printed on 100 percent FSC-certified paper.